Images for the End
of the Century

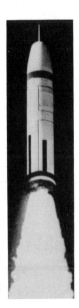

For Daniel and Matthew

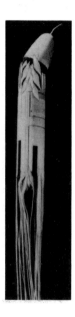

This book is published to coincide with the exhibition 'Images for the End of the Century' by Peter Kennard at the Imperial War Museum, London, and the Gimpel Fils Gallery, London 1990.

IMAGES FOR THE END OF THE CENTURY

Photomontage Equations

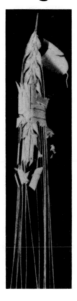

Peter Kennard

Journeyman Press
London

First published in 1990 by Journeyman Press
345 Archway Road, London N6 5AA
and Winchester Place, Winchester, Mass. 01890, USA

ISBN 1 85172 032 4 pb
ISBN 1 85172 033 2 hb

Printed in United Kingdom by Cheney and Sons Ltd, Banbury

'In investigating history we are not flicking through a series of "stills", each of which shows us a moment of social time transfixed into a single eternal pose: for each one of these "stills" is not only a moment of being but also a moment of becoming: and even within each seemingly-static section there will be found contradictions and liaisons, dominant and subordinate elements, declining or ascending energies. Any historical moment is both a result of prior process and an index towards the direction of its future flow.'

E.P. Thompson, *The Poverty of Theory and Other Essays* (London: Merlin Press, 1978)

'If I could do it, I'd do no writing at all here. It would be photographs; the rest would be fragments of cloth, bits of cotton, lumps of earth, records of speech, pieces of wood and iron, phials of odors, plates of food and of excrement.'

James Agee, *Let Us Now Praise Famous Men* (New York: Ballantine Books, 1939)

Over the years there have been a great number of people who have helped and encouraged my work, a list too long to quote here. But for this book I would like to thank Angela Weight and Robin Hamilton from the Imperial War Museum and Rene Gimpel and Simon Lee from the Gimpel Fils Gallery who organised the exhibition, 'Images for the End of the Century'; Anne Beech from Pluto Press who believed it could make a good book and Judy Barker who gave me time and support to do it. Also thanks to Josephine Fraga Ribeiro, Coll M. Hunter and Konstantin Volkov from the United Nations and Related Agencies Staff Movement for Disarmament and Peace for organising my exhibition at the United Nations in Geneva which led directly to this book, and to all the photographers whose work I have used, especially Jenny Matthews and Ed Barber.

Some of the photomontages in this book were first produced for the following organisations and publications to whom I am grateful: Camerawork, Campaign for Nuclear Disarmament, Gaia Books, Greater London Council, *Guardian*, Impressions Gallery, the Labour Party, *New Musical Express*, *New Scientist*, Penguin Books, *Sunday Times, Time Out* and Workers Press.

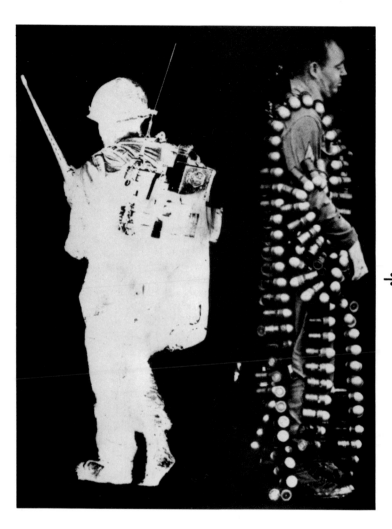

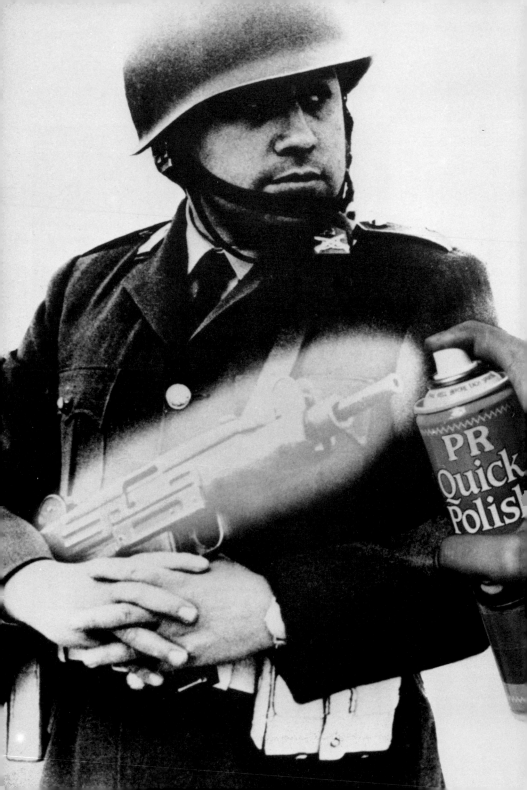

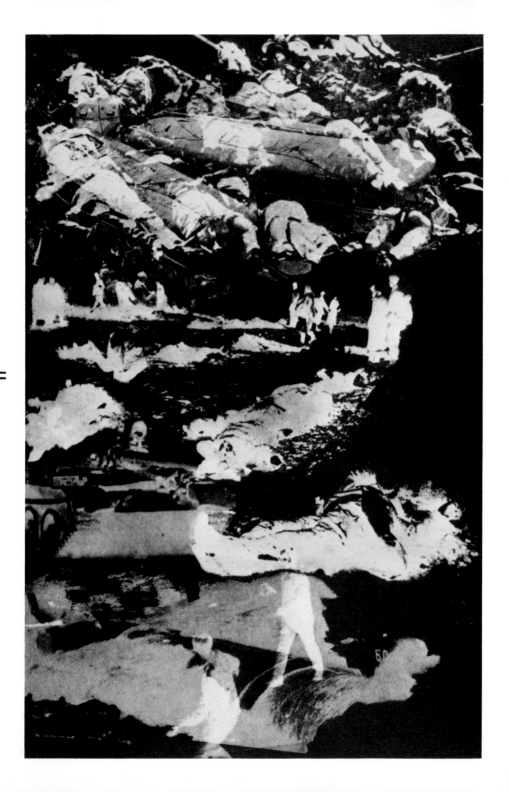

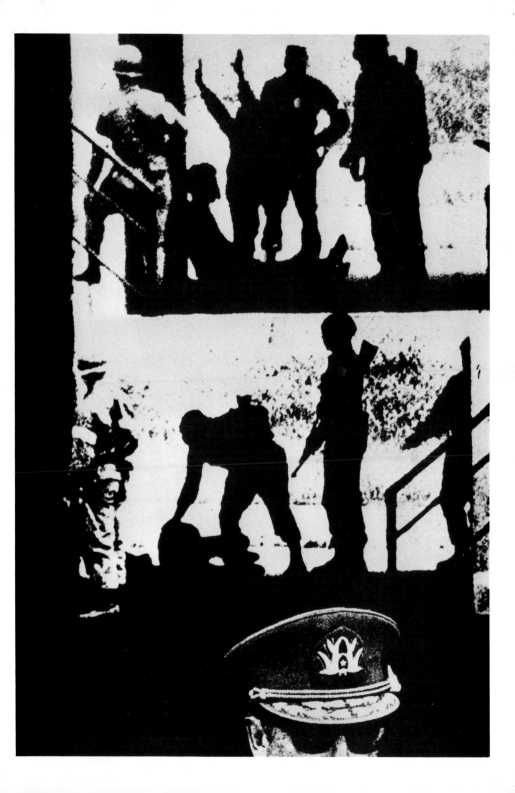

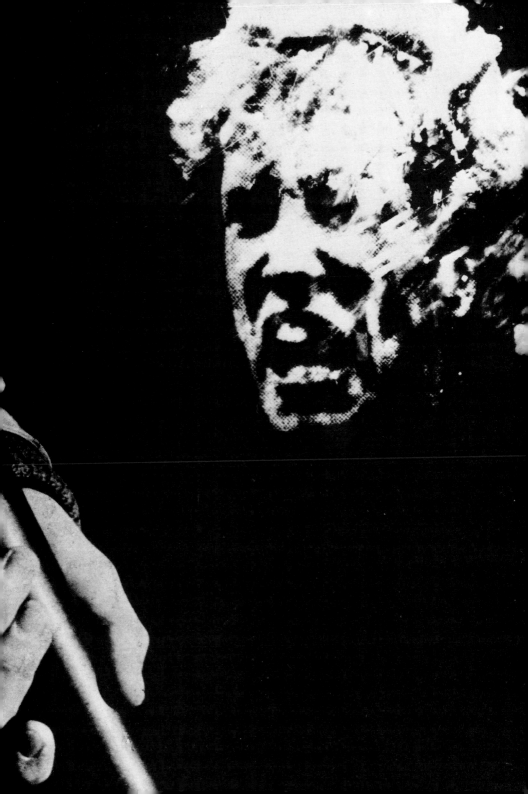

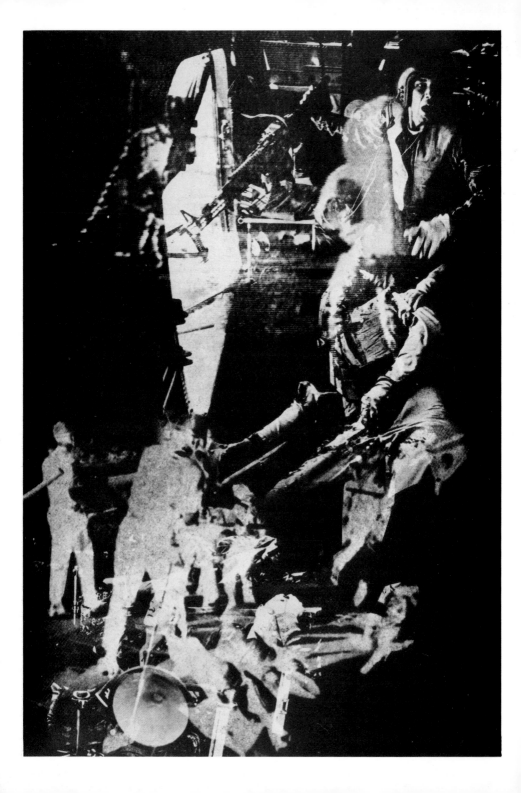

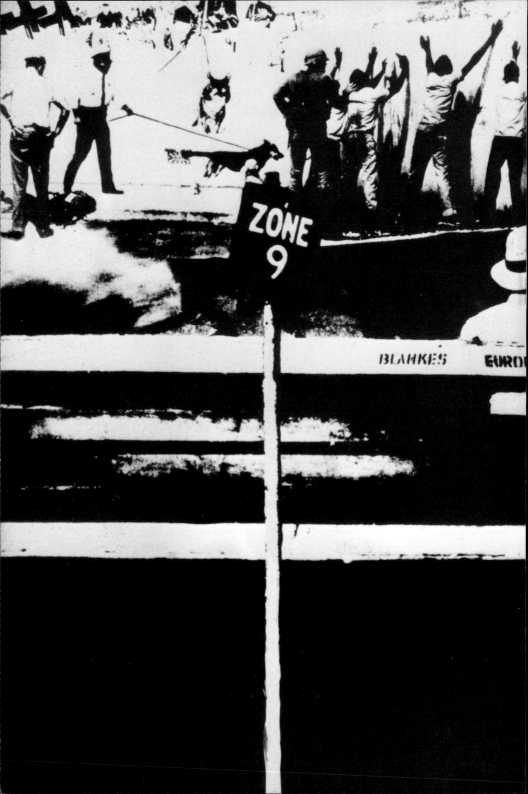

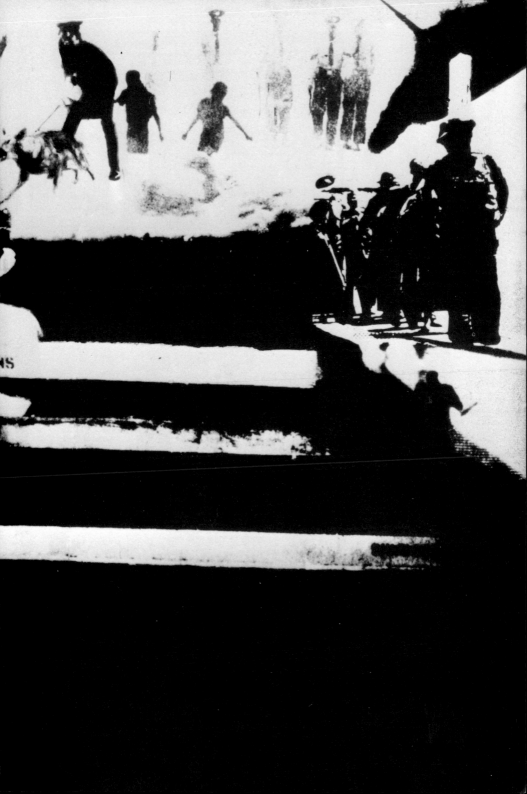

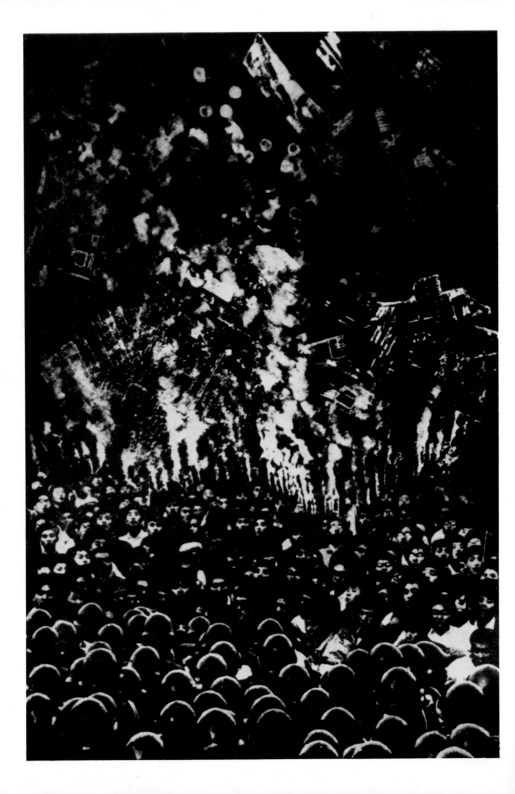

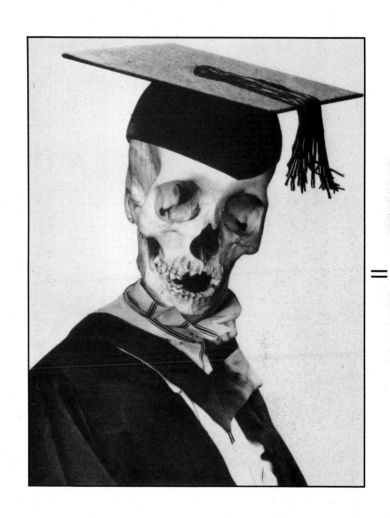

=

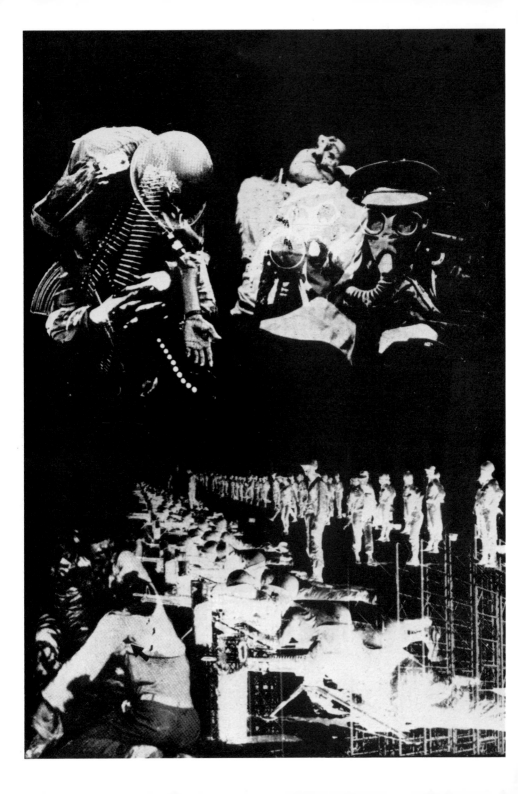

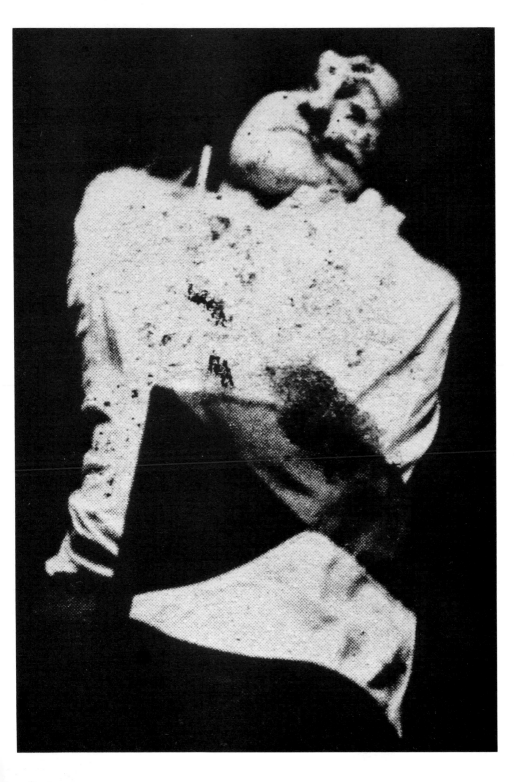

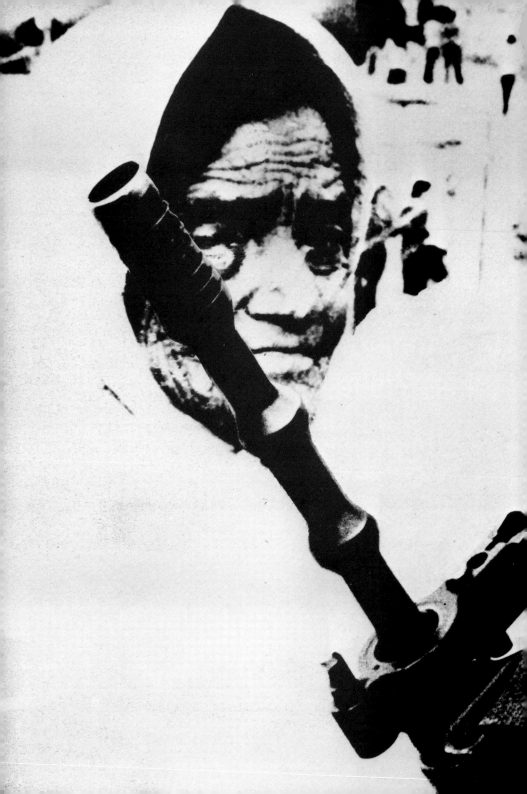

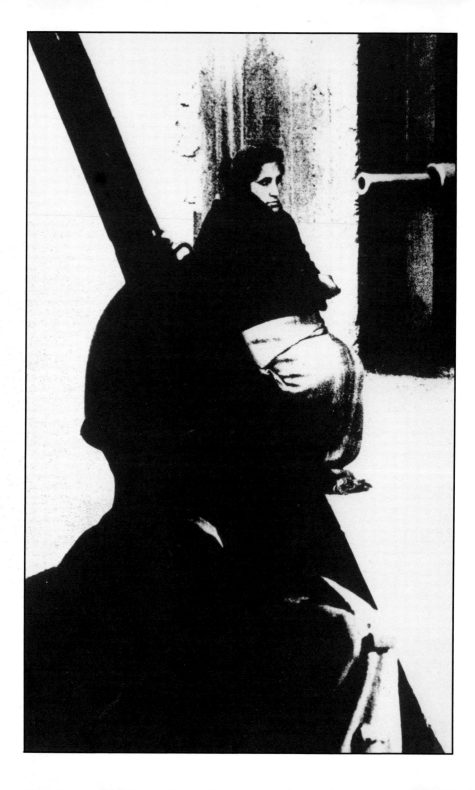

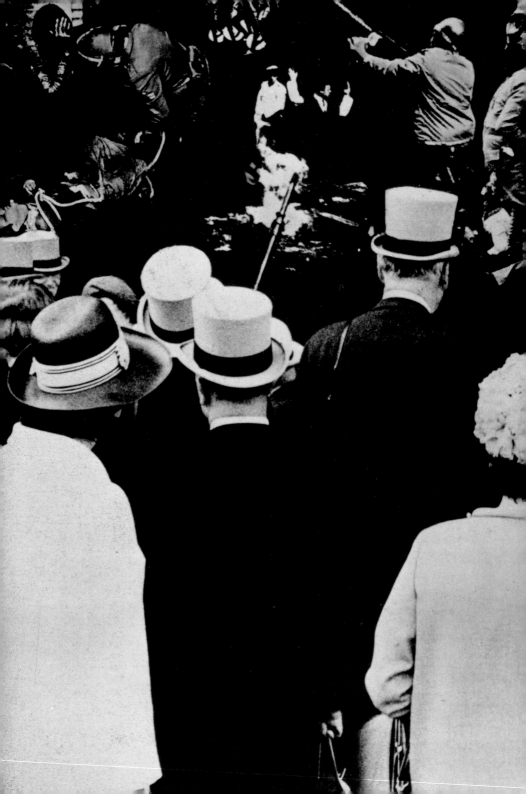

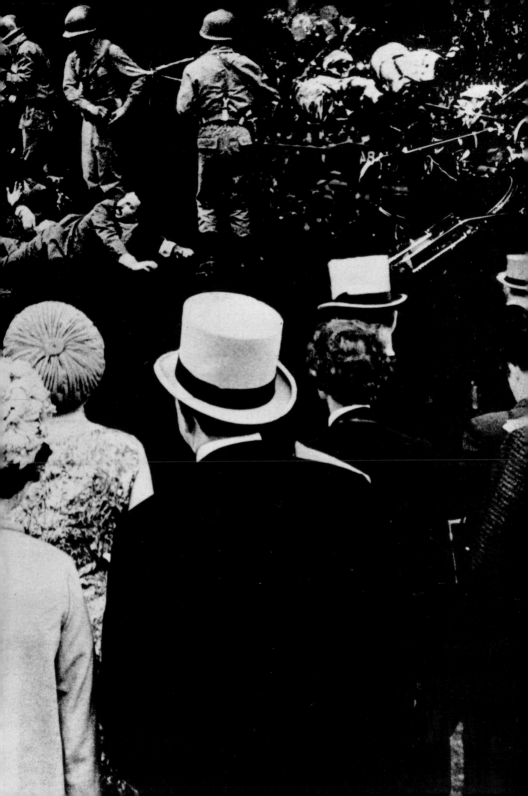

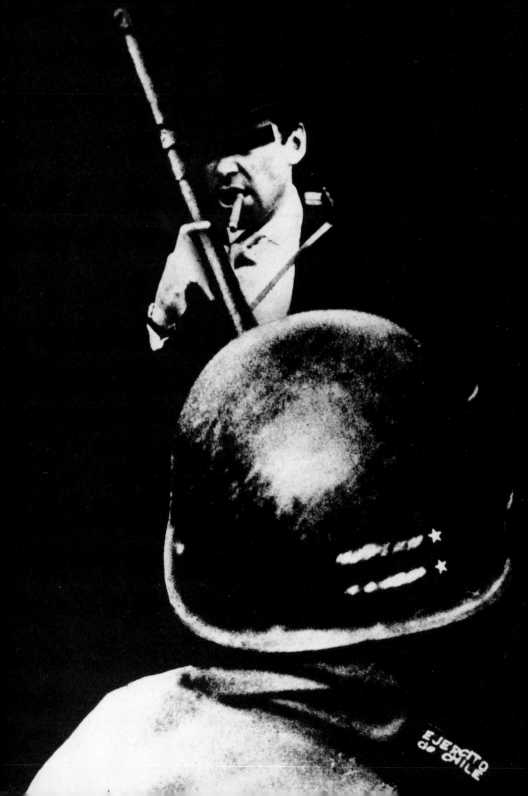

= 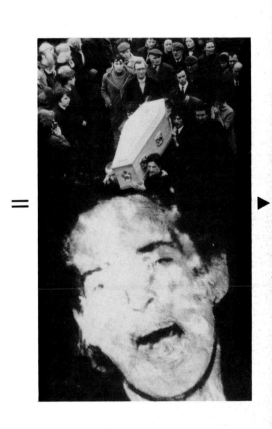 ▶

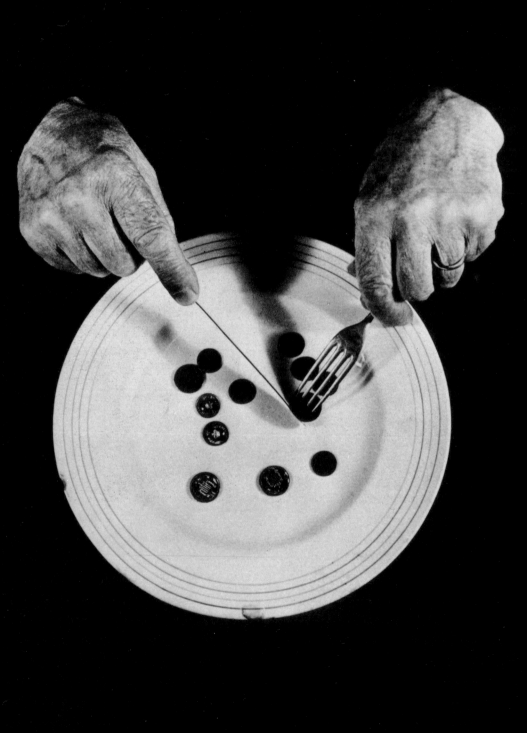

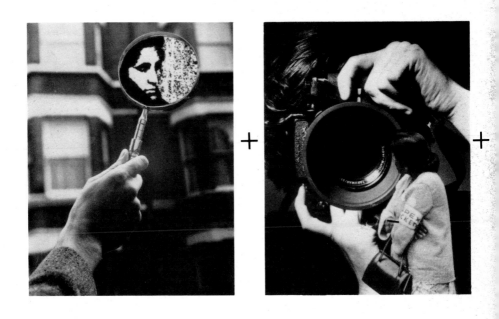

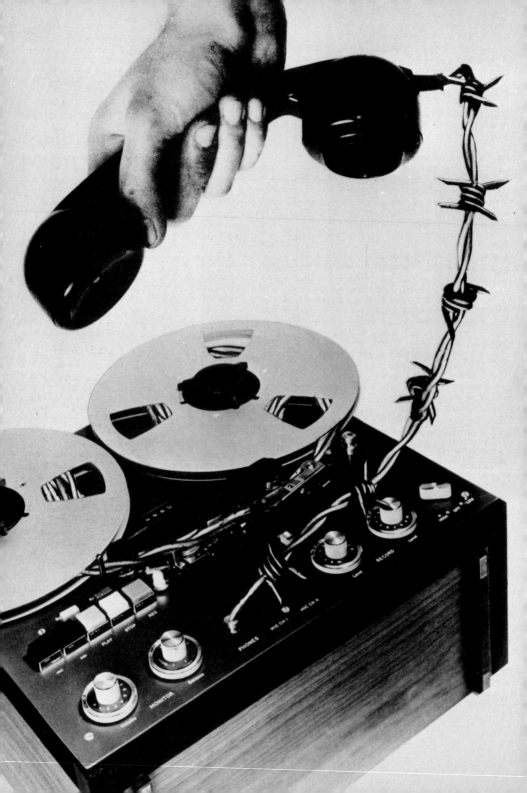

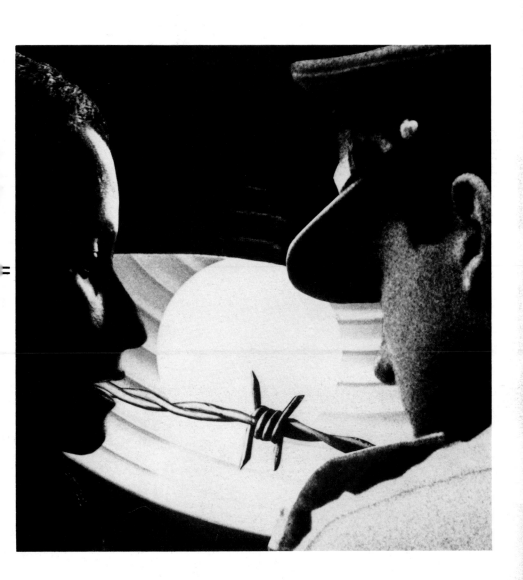

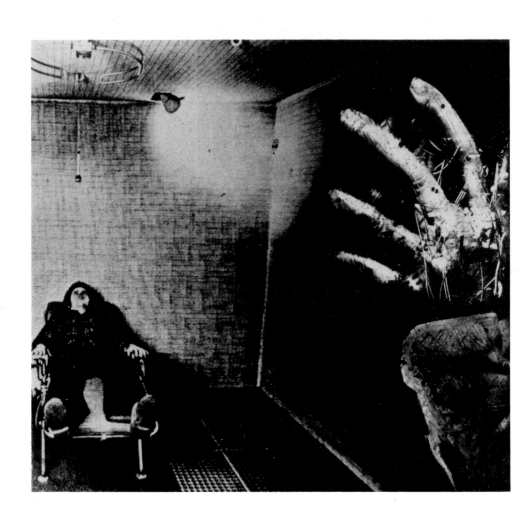

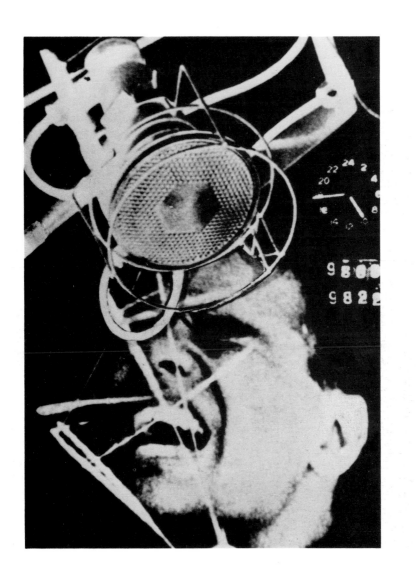

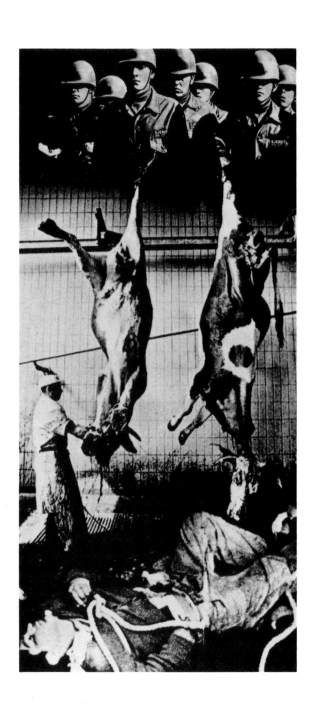

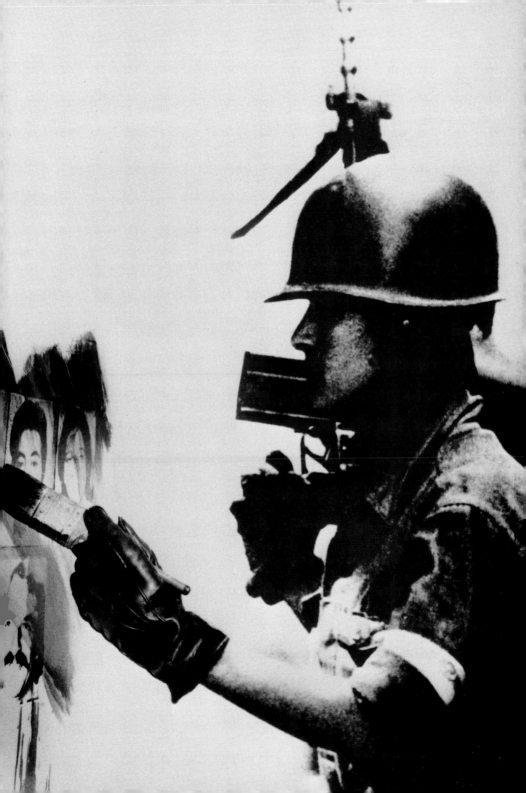

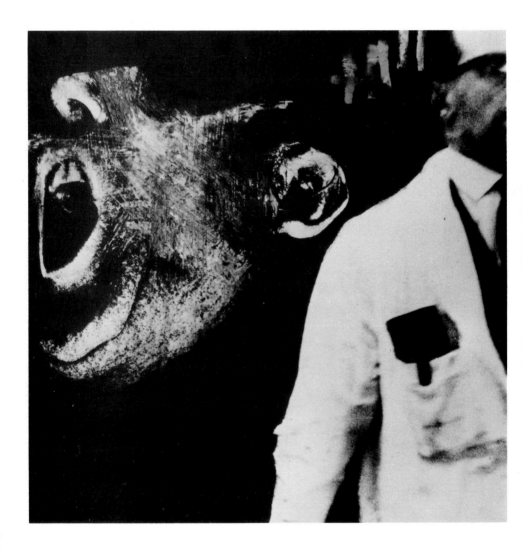

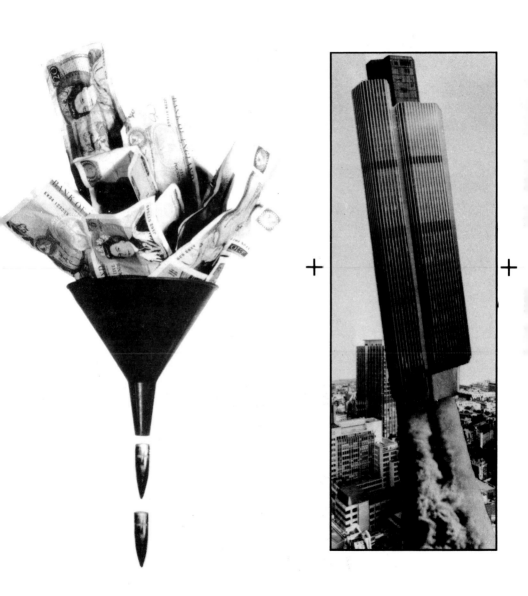

\+ \+

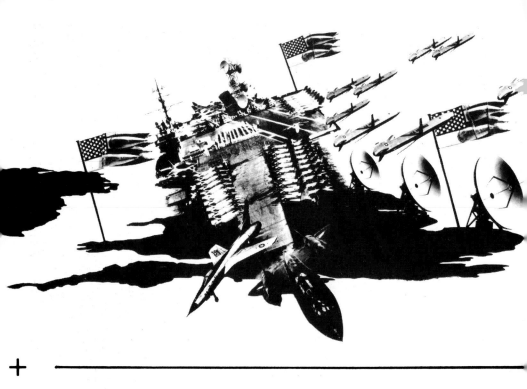

+ ───

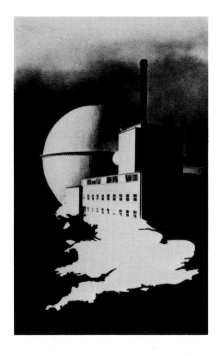

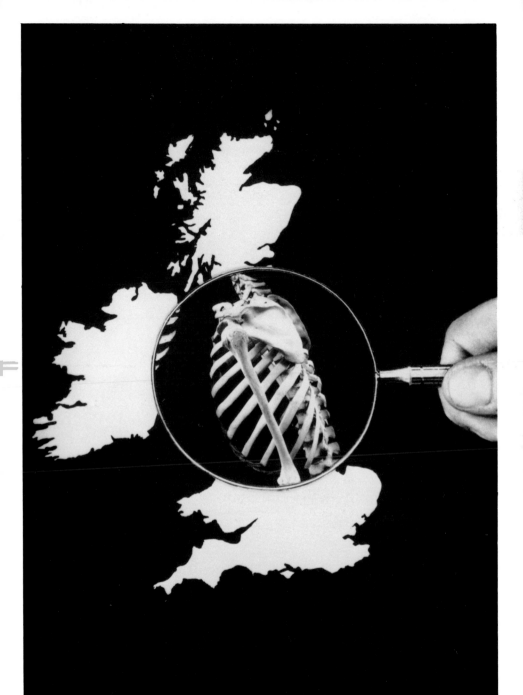

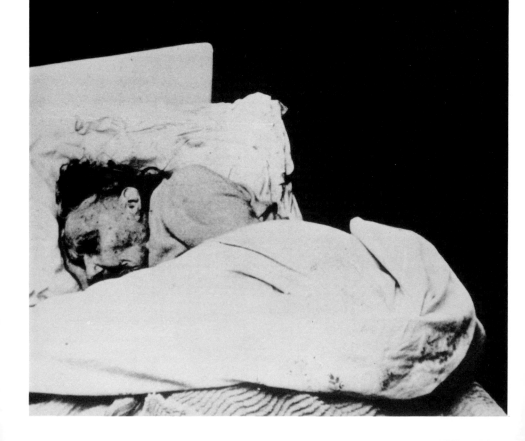

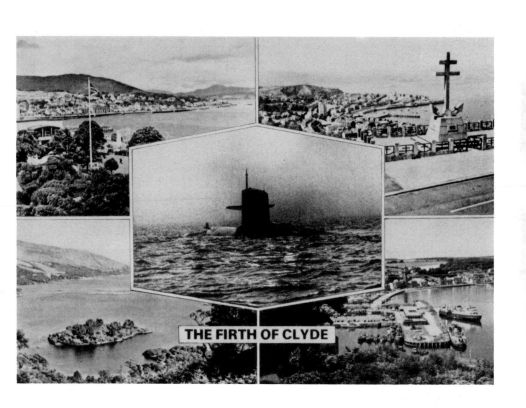

THE FIRTH OF CLYDE

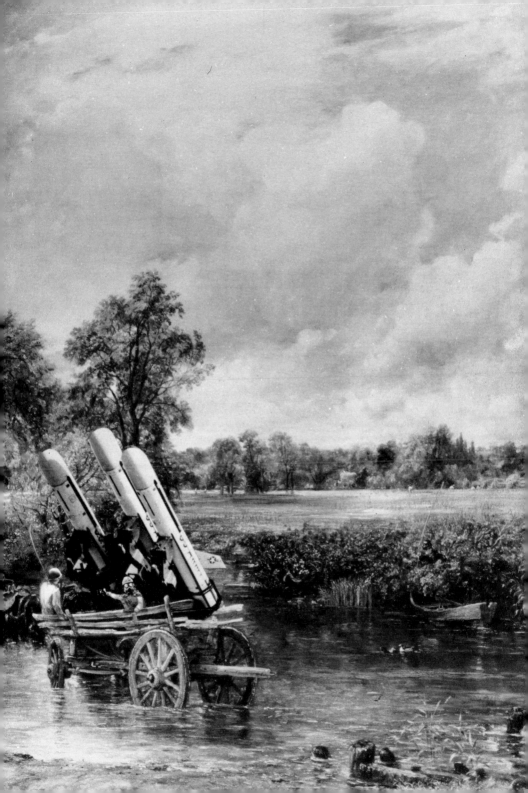

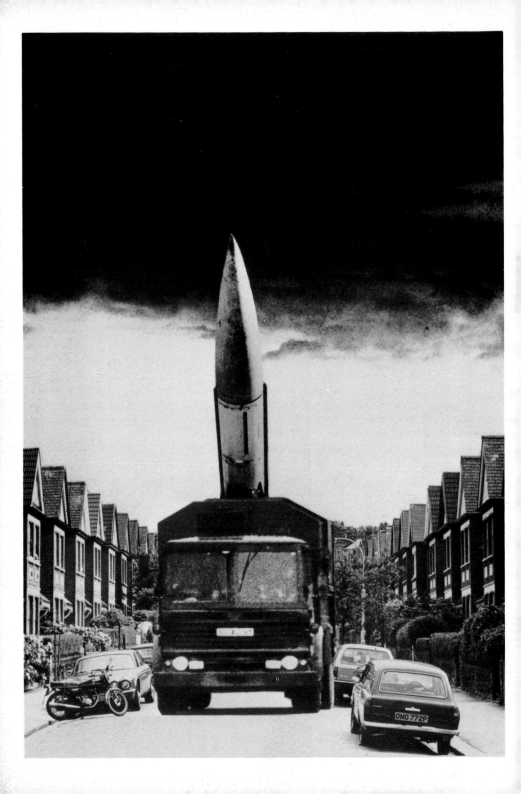

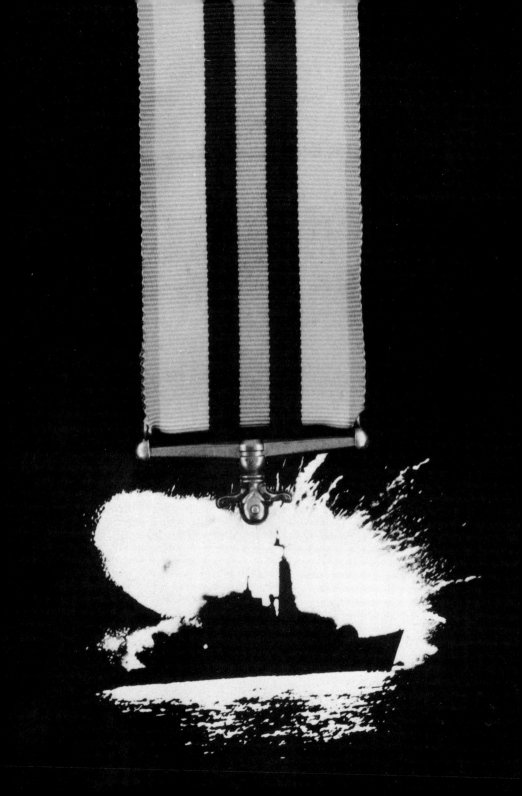

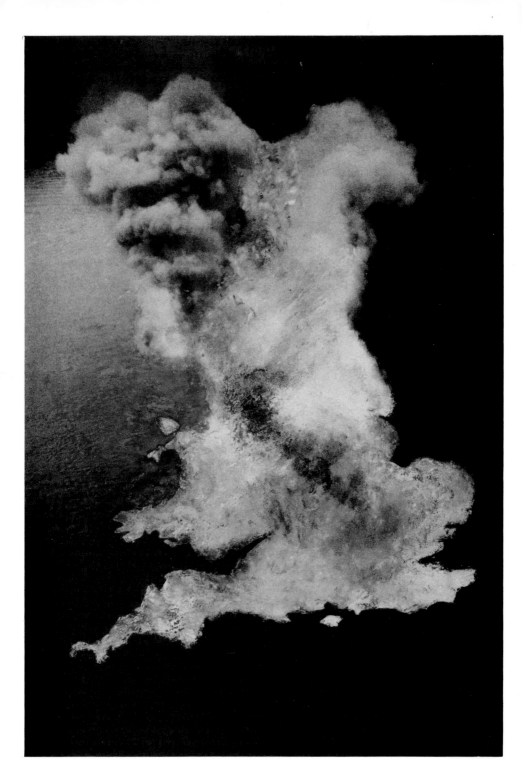





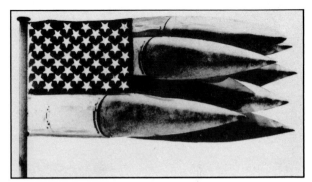

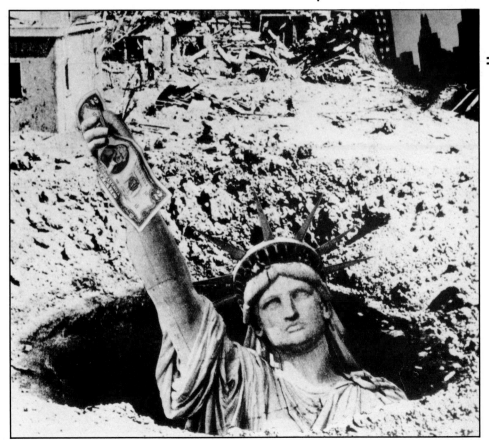

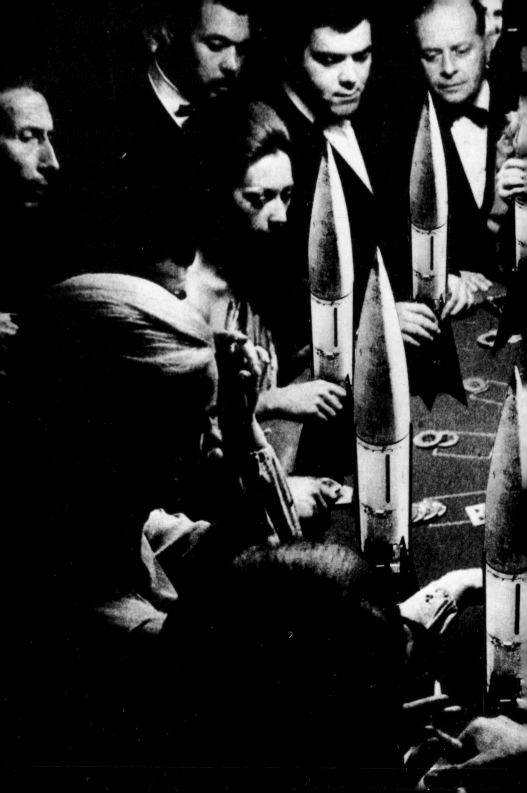

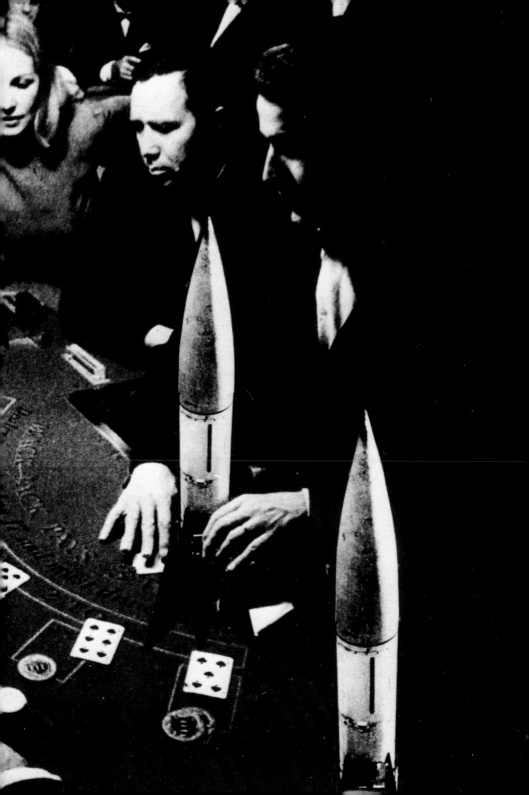

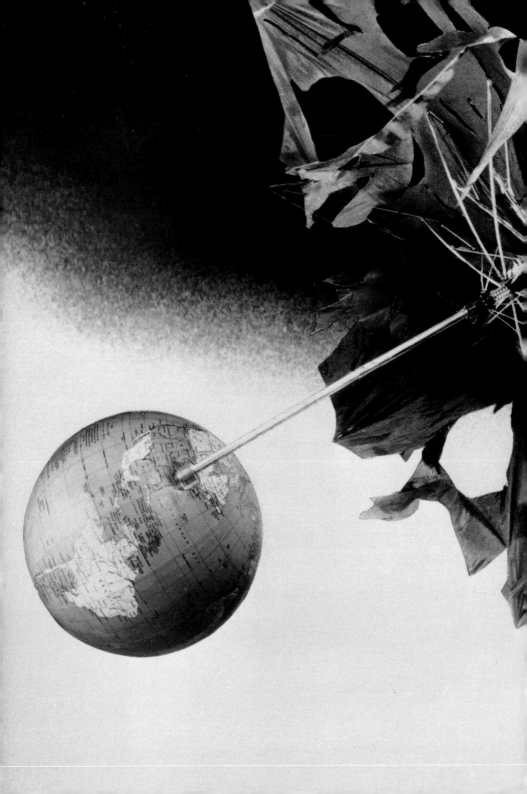

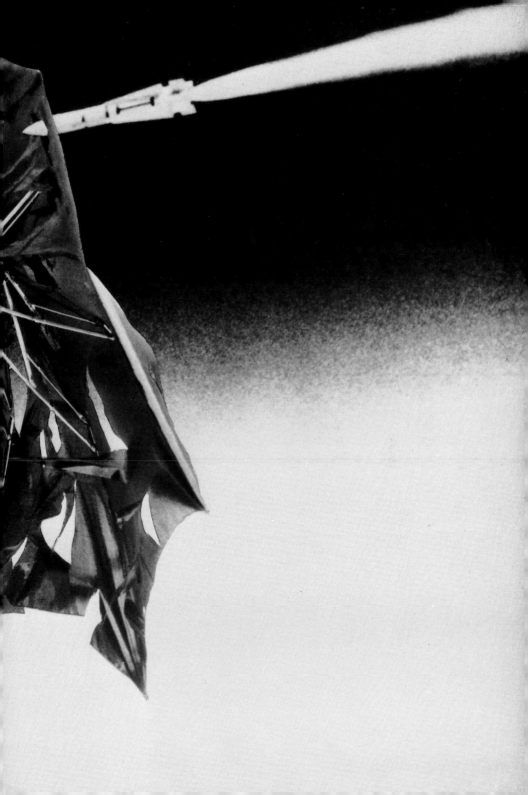

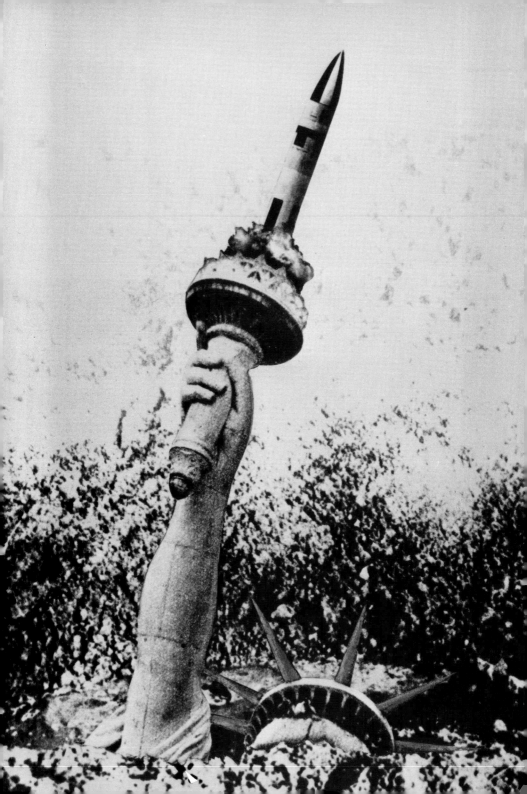

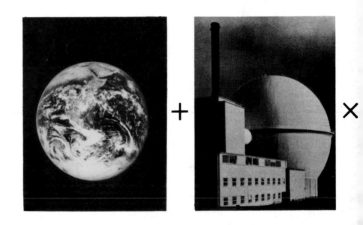

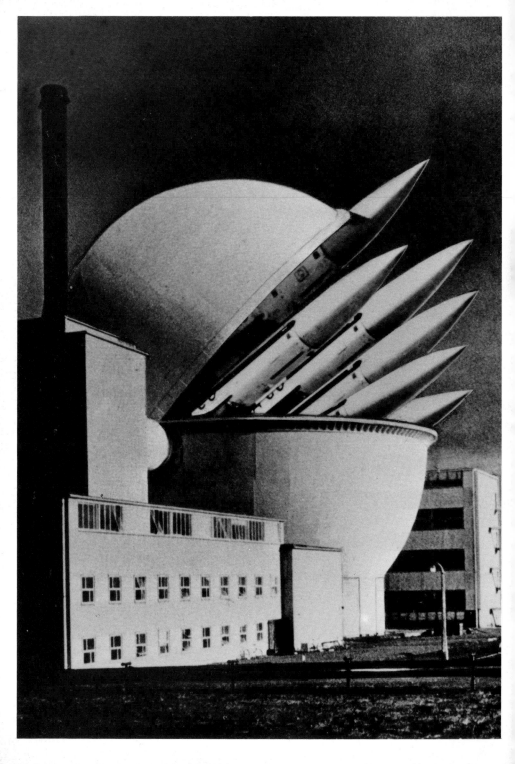

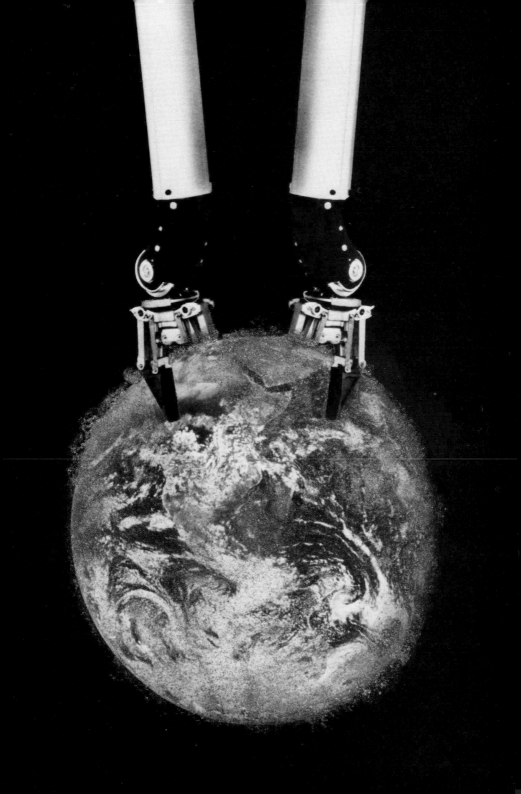

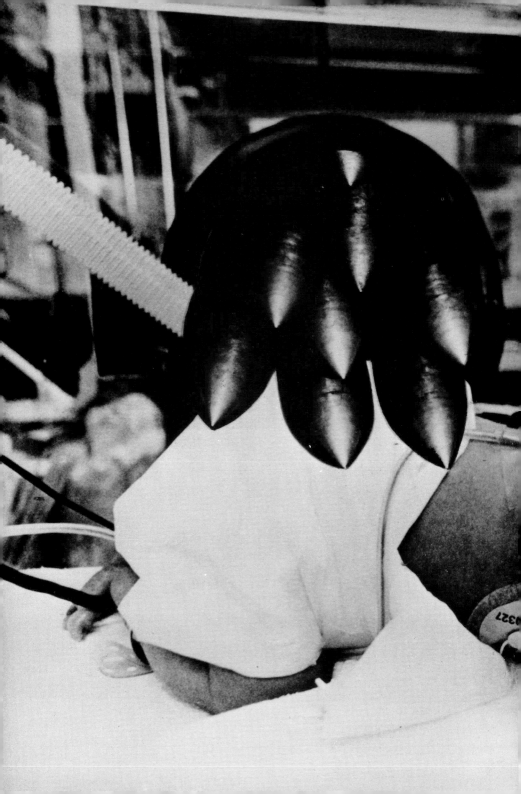

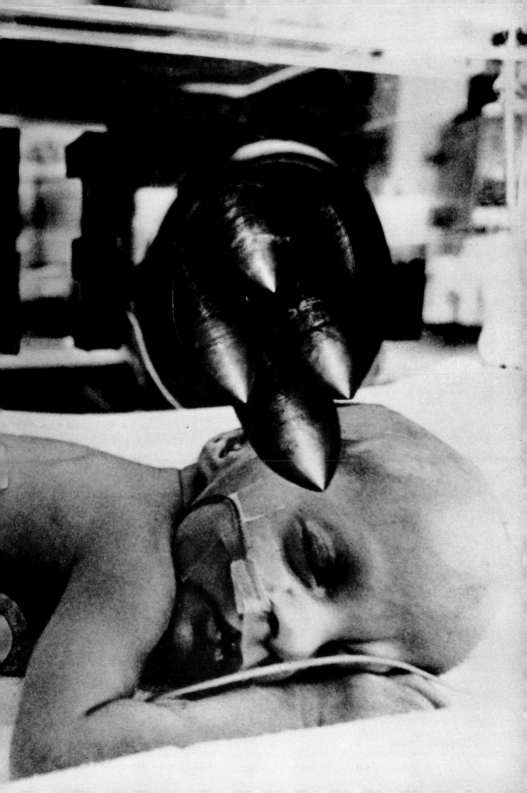

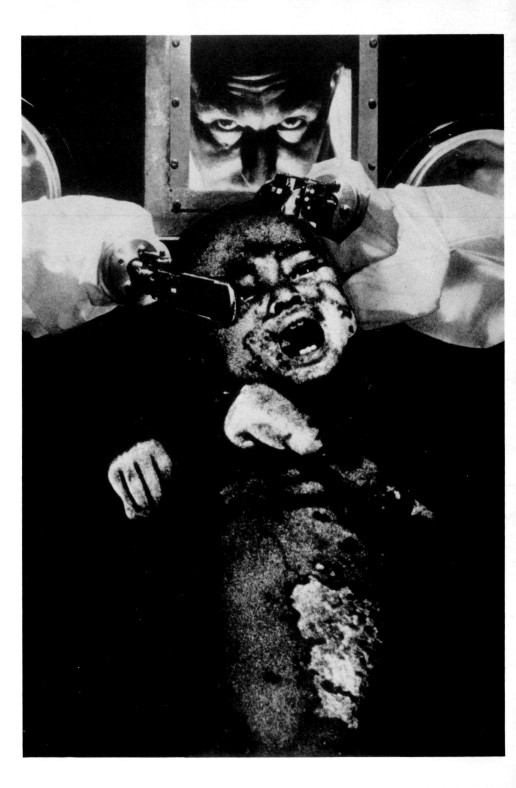

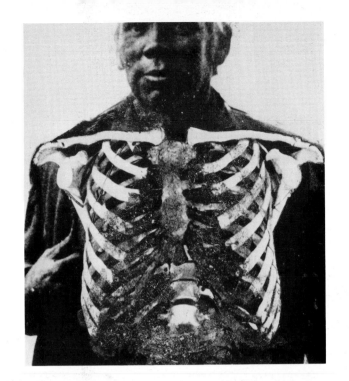

=

▶

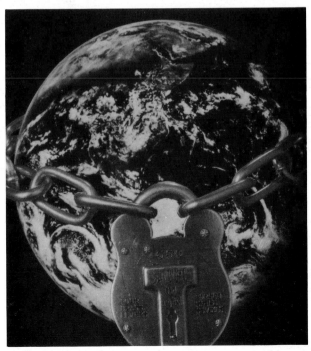

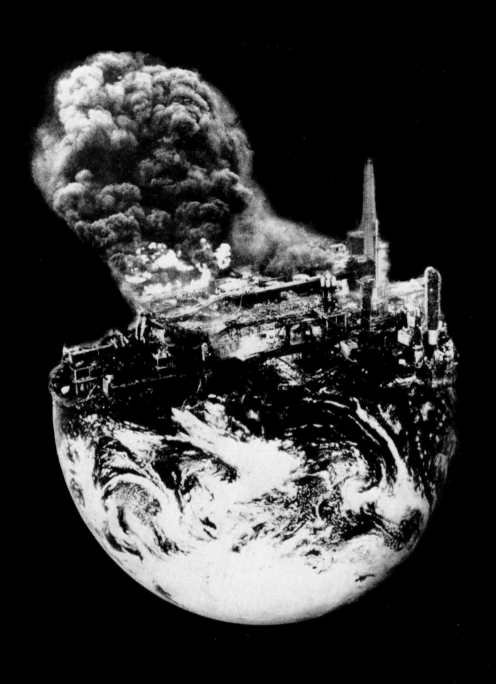

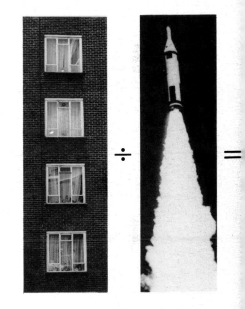

÷

=

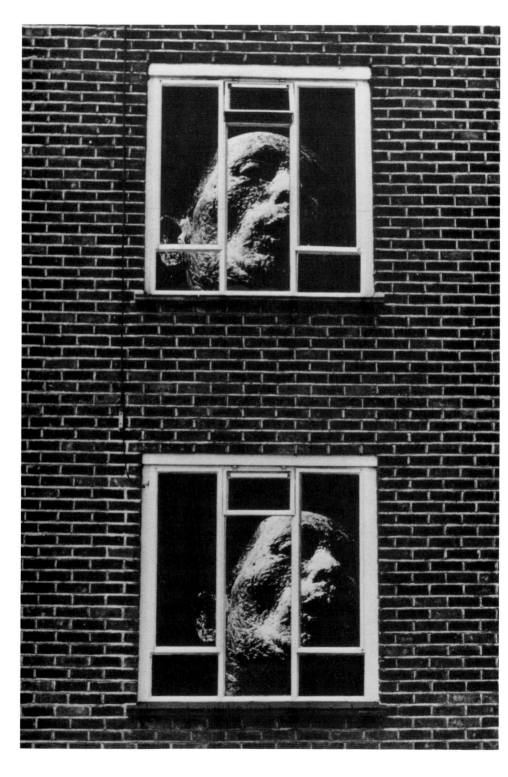

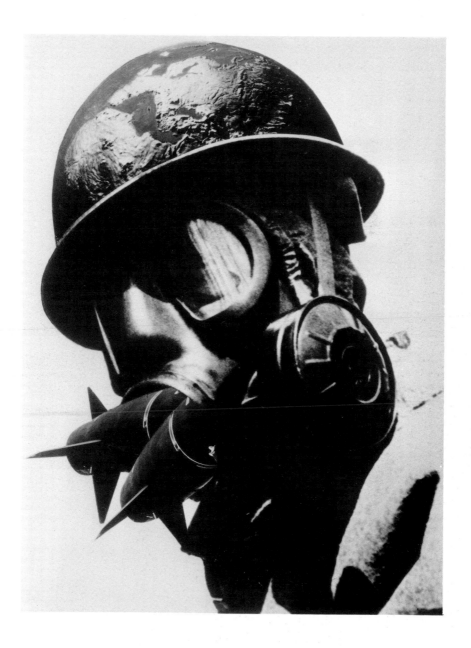

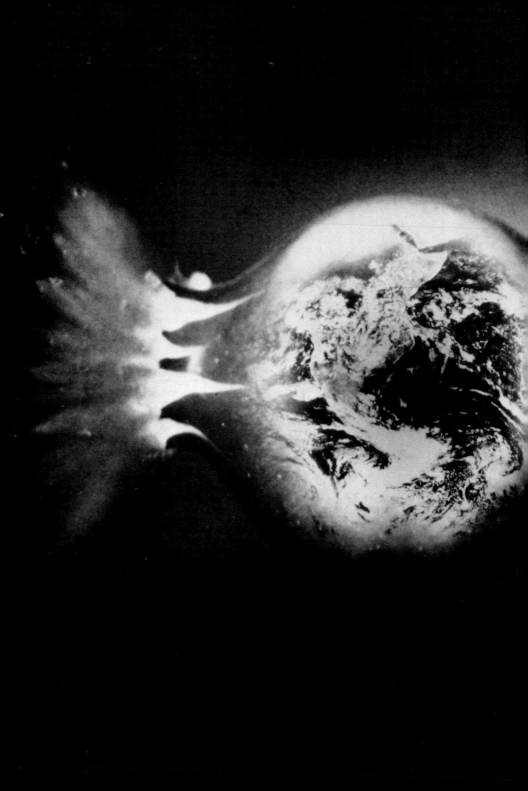

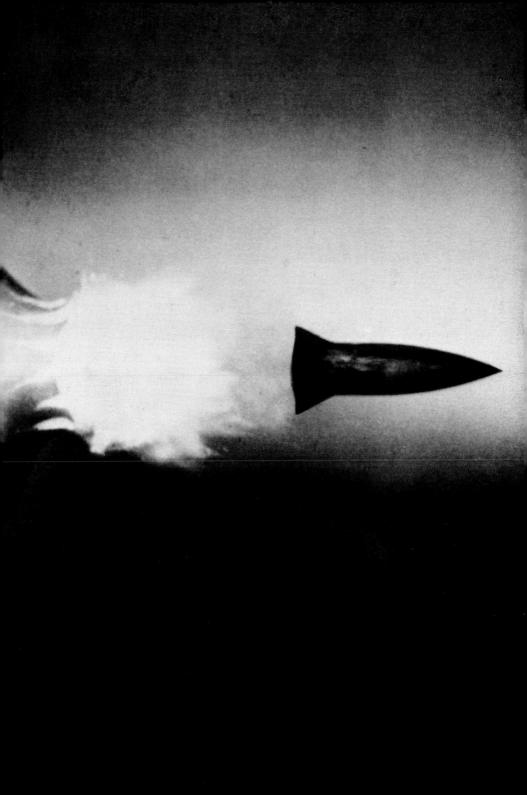

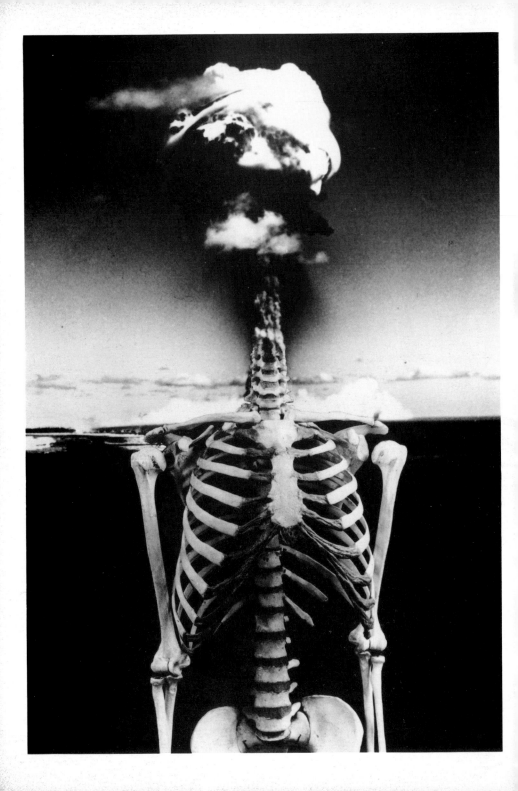

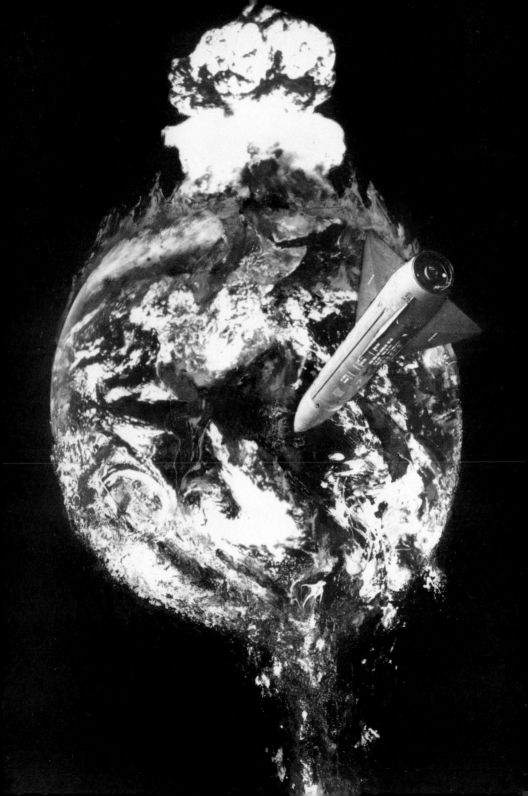

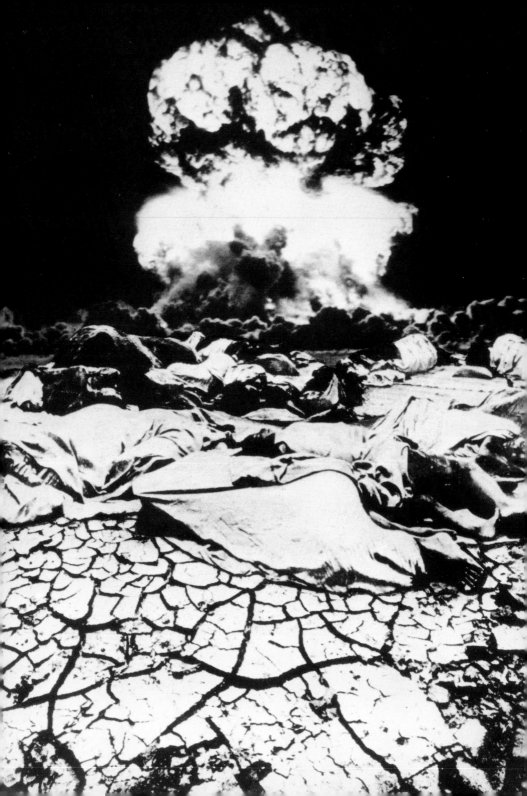

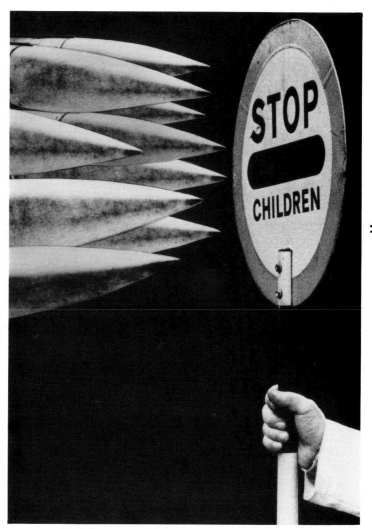

≠

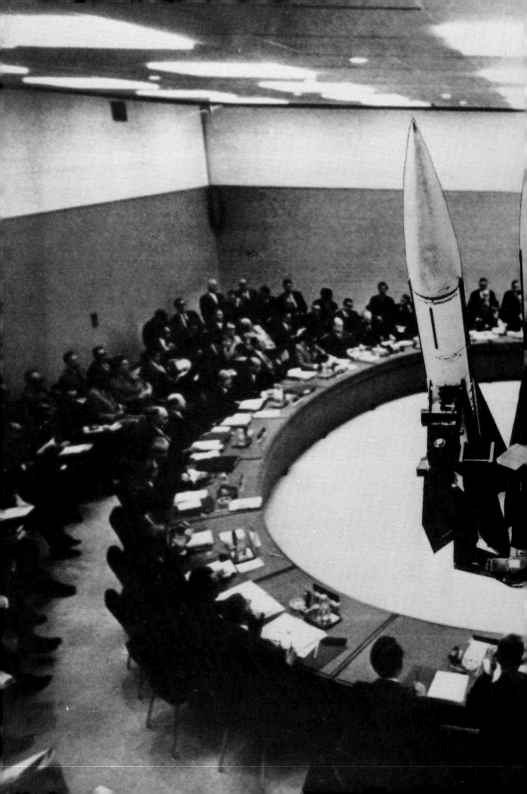

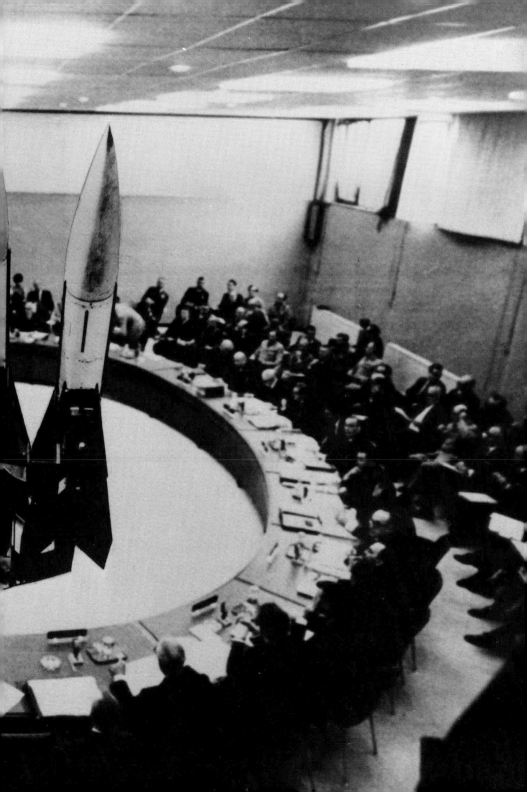

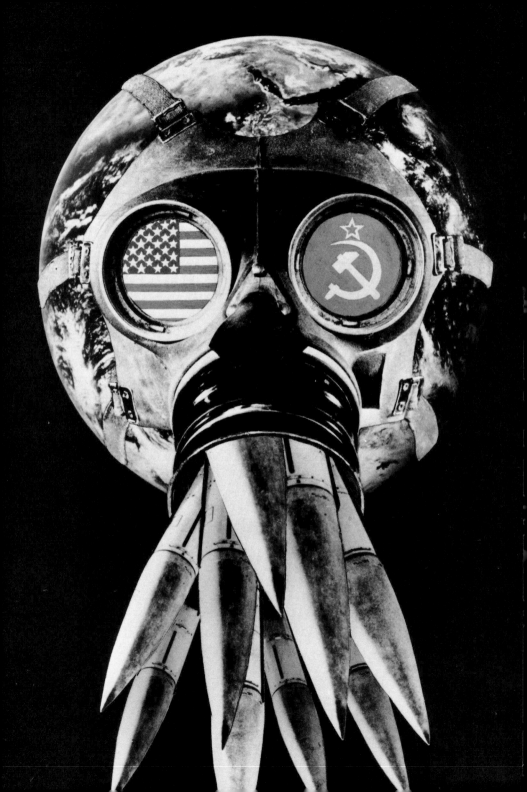

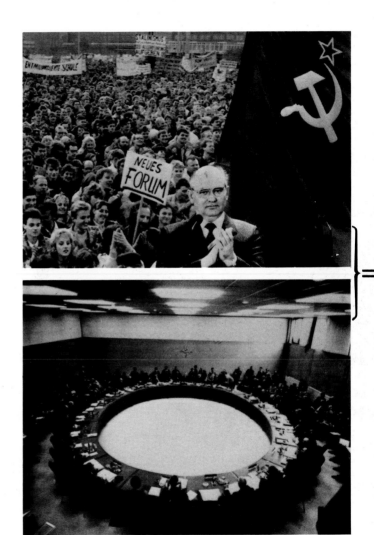

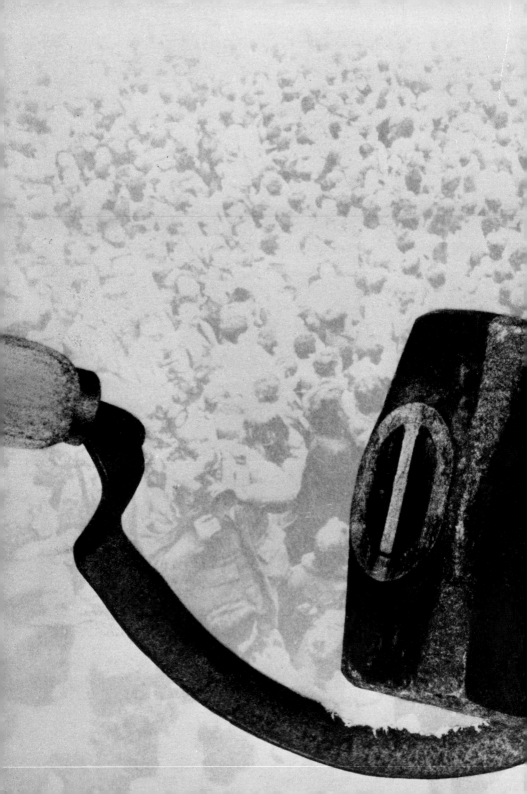

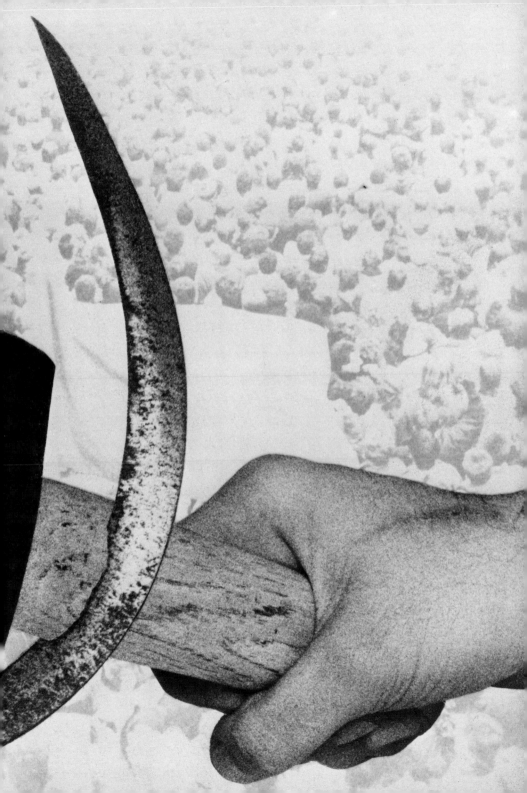

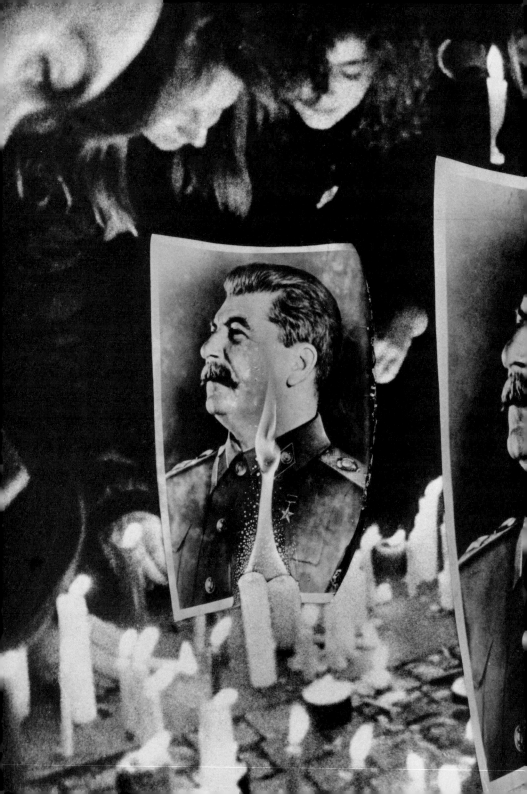

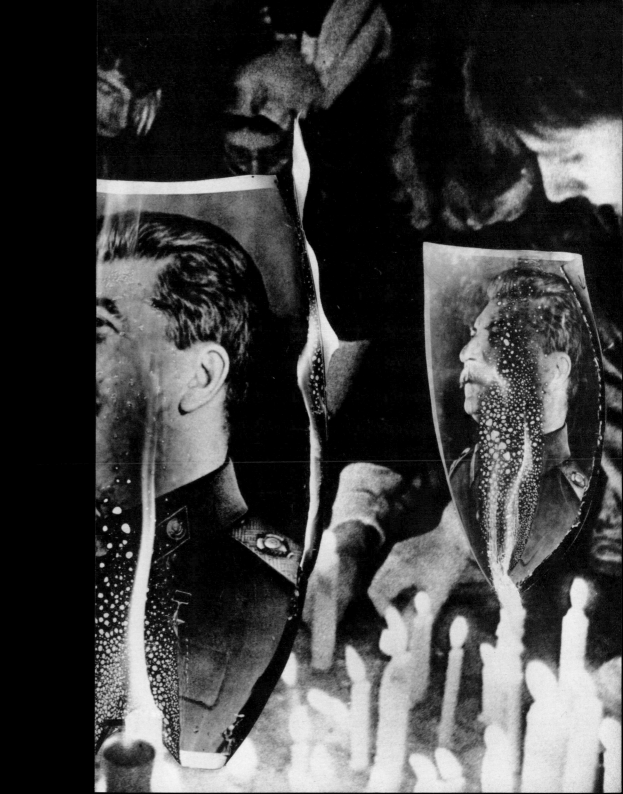

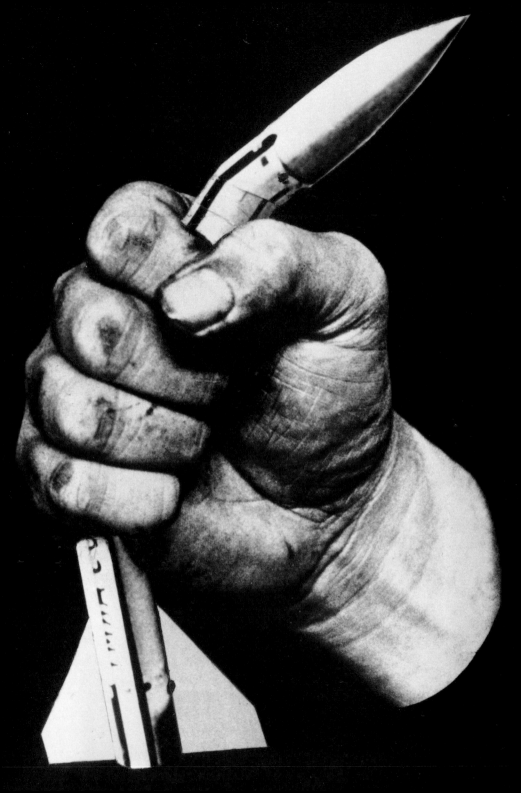

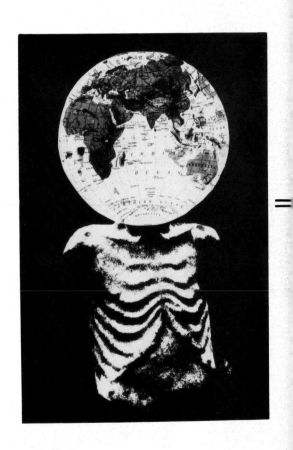

=

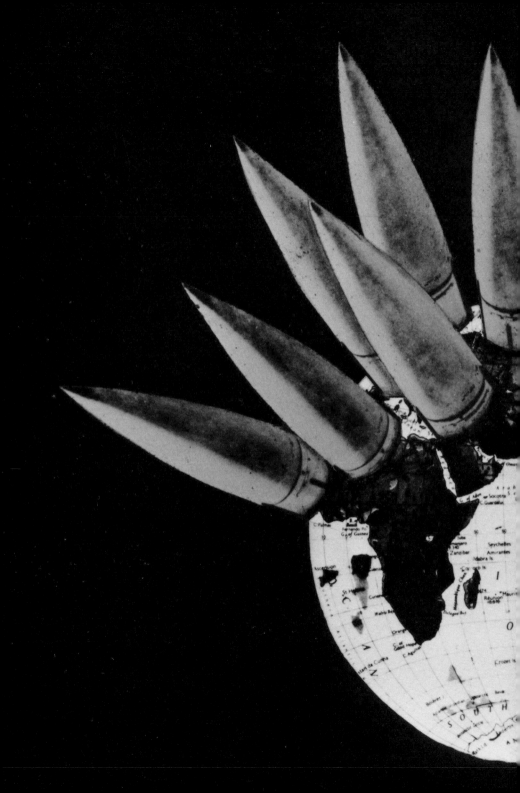

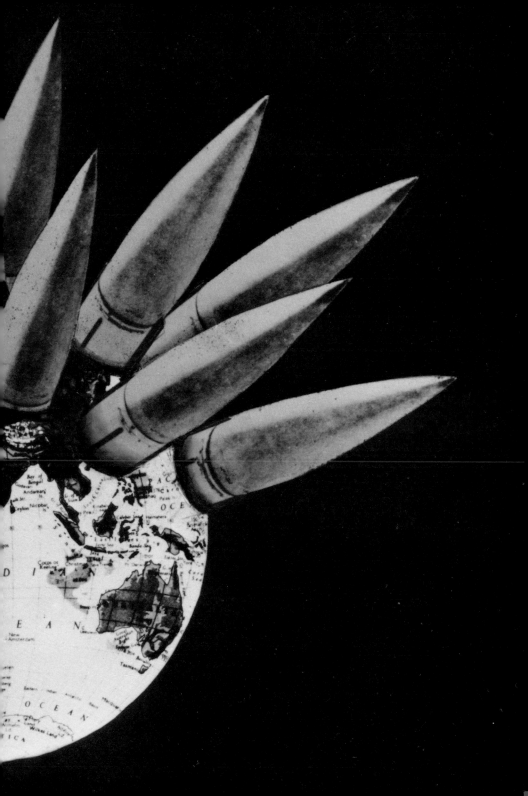

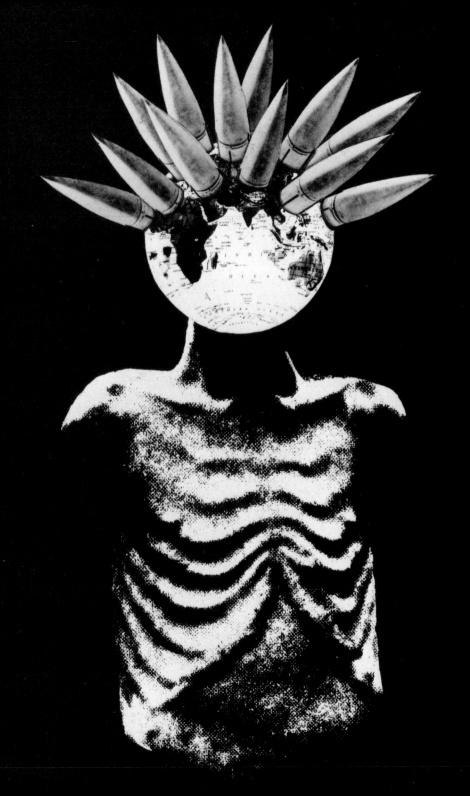

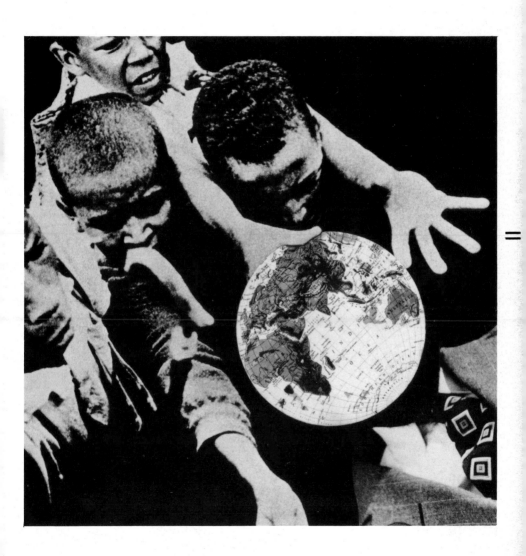

=

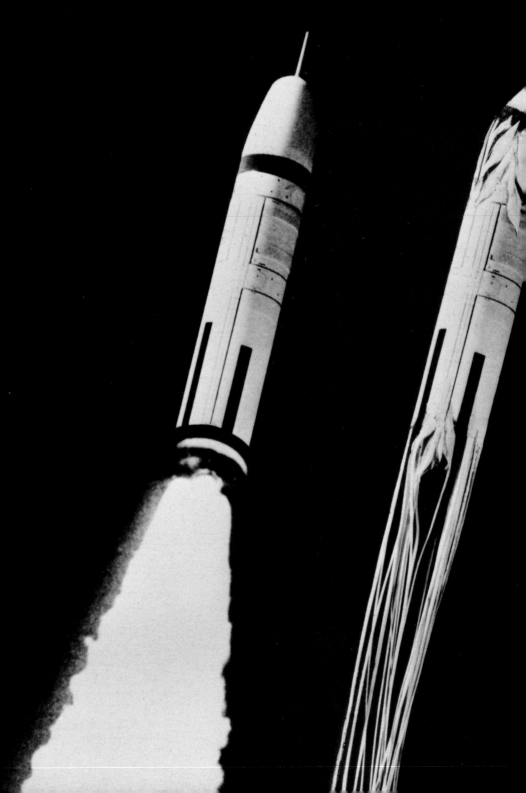

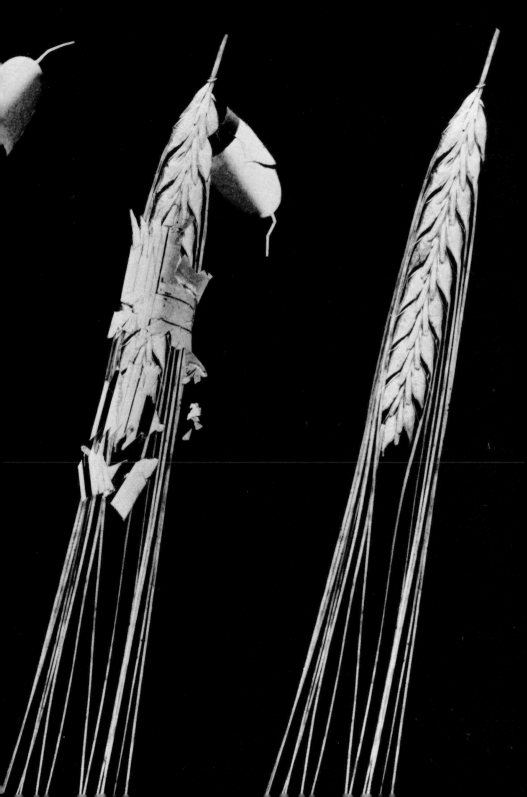

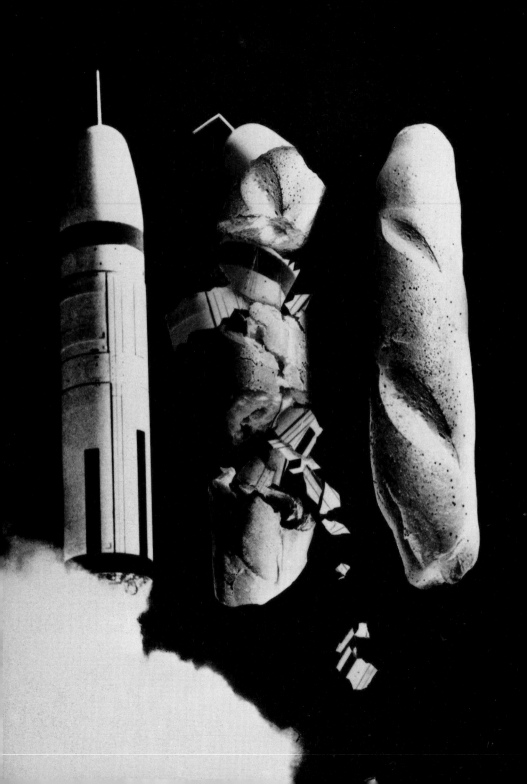

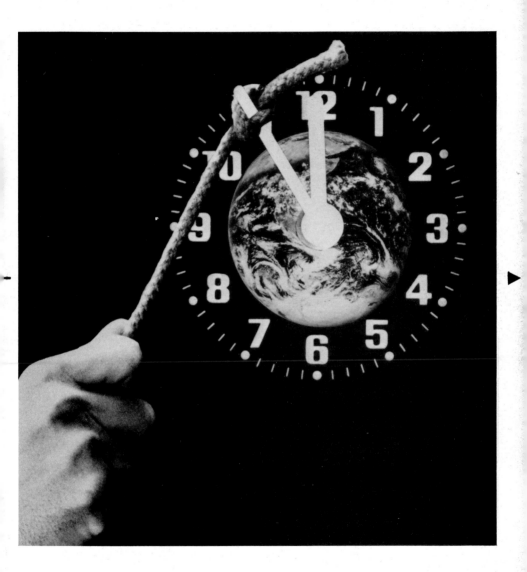

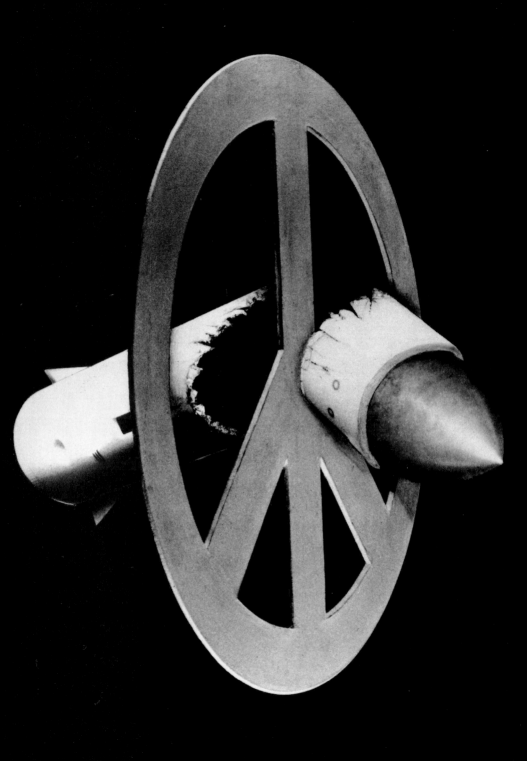

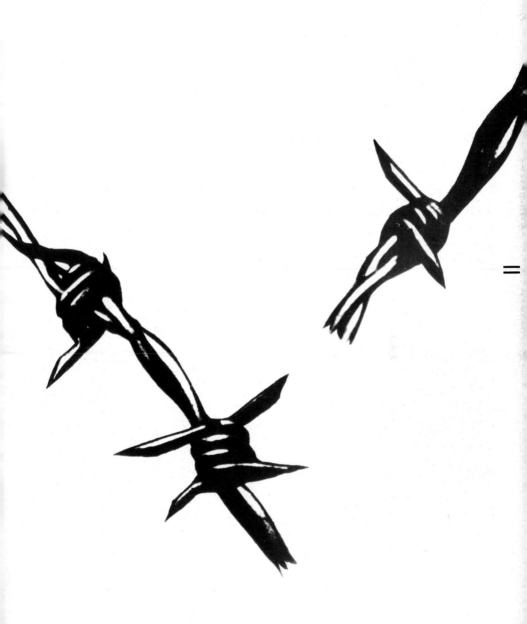

=

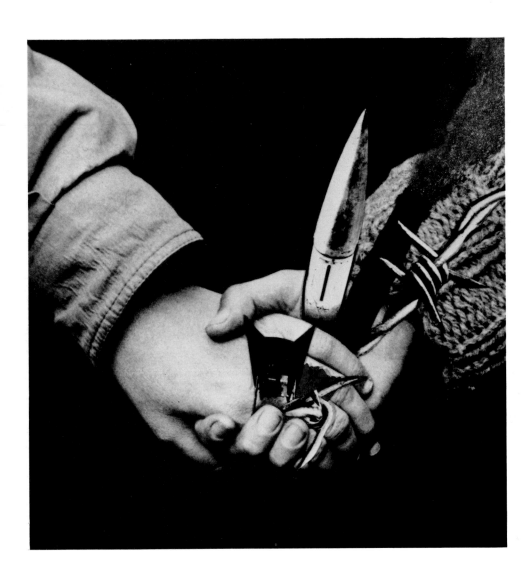

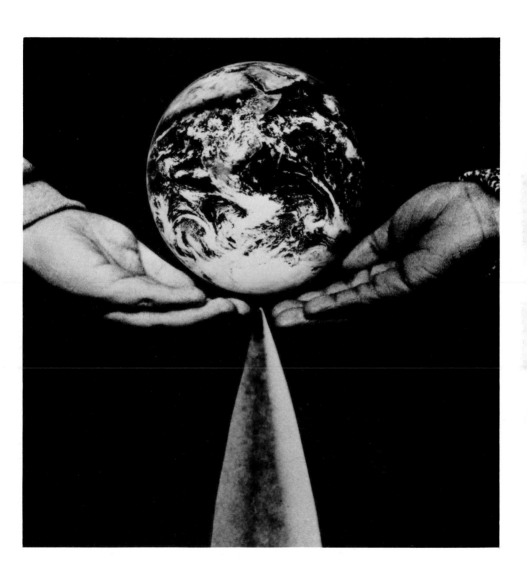

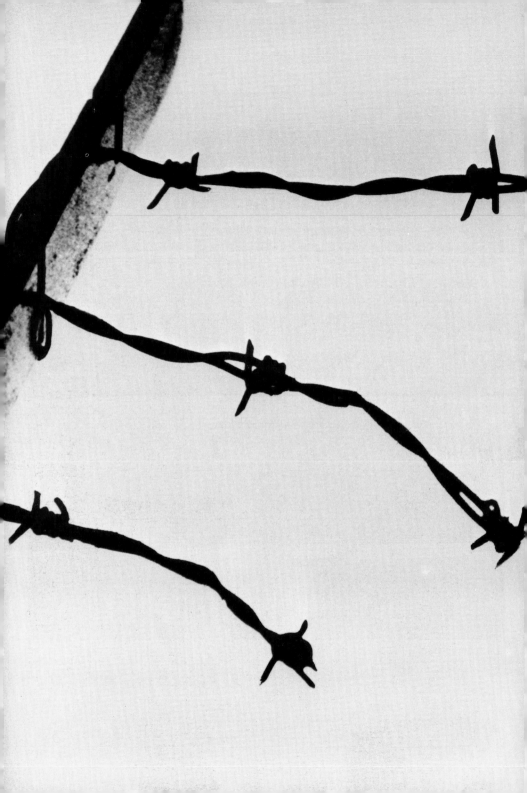

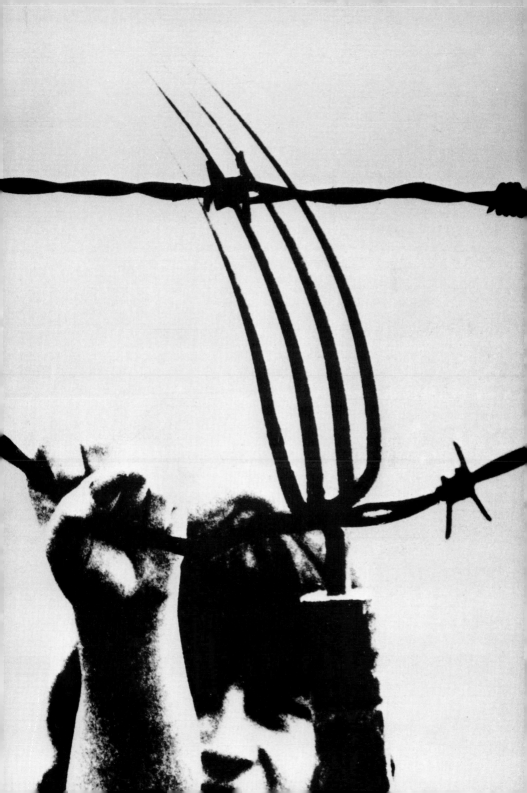

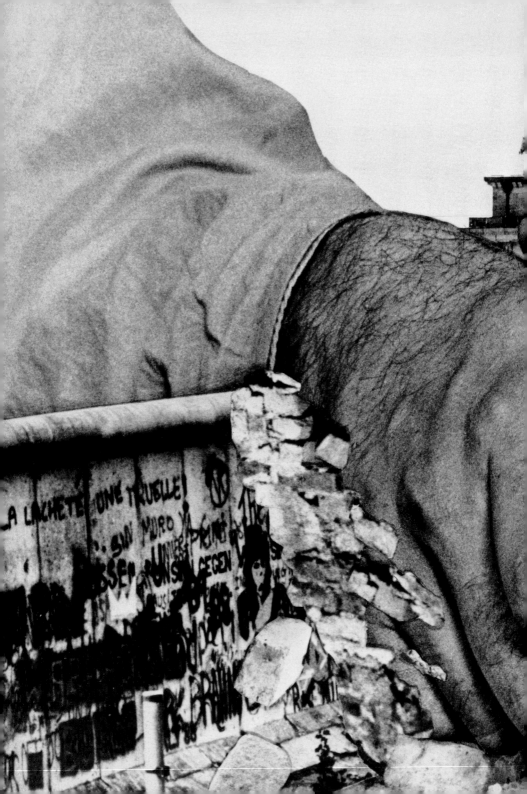

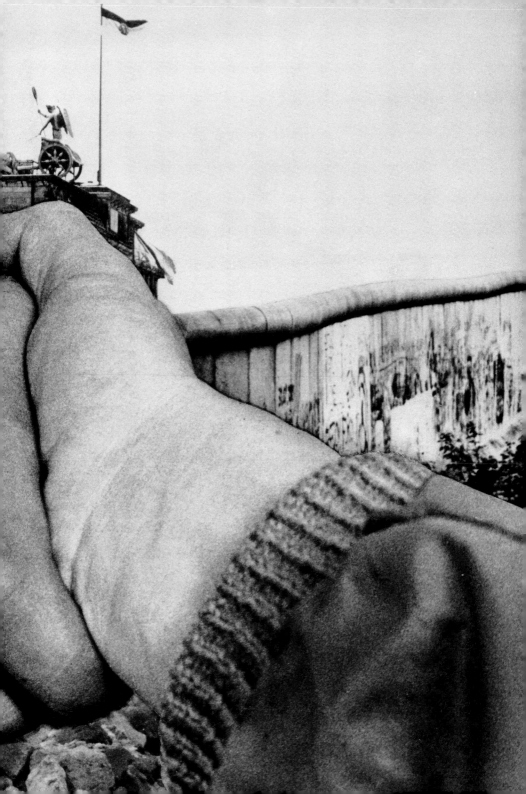

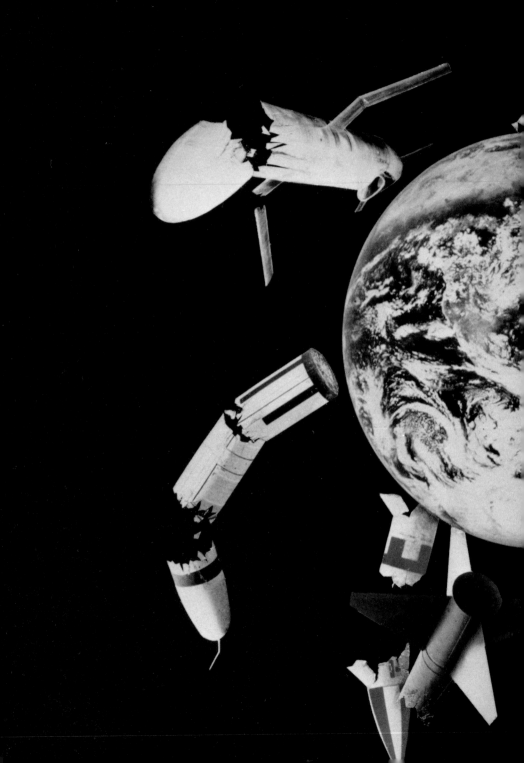

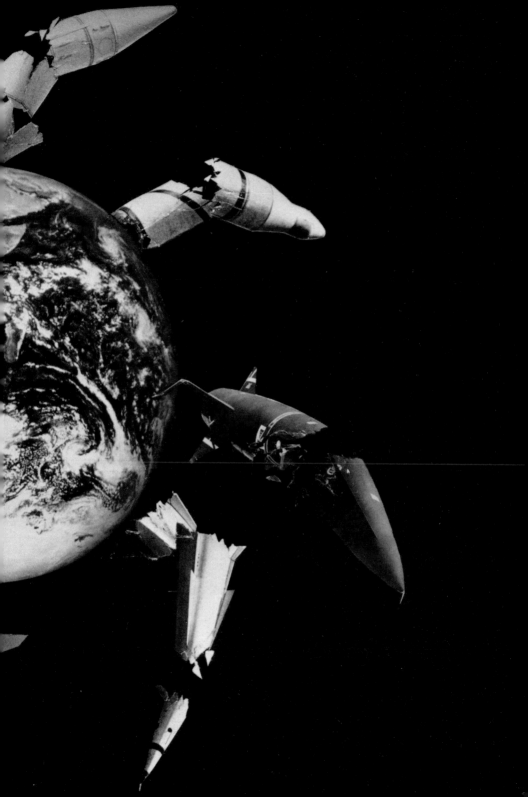

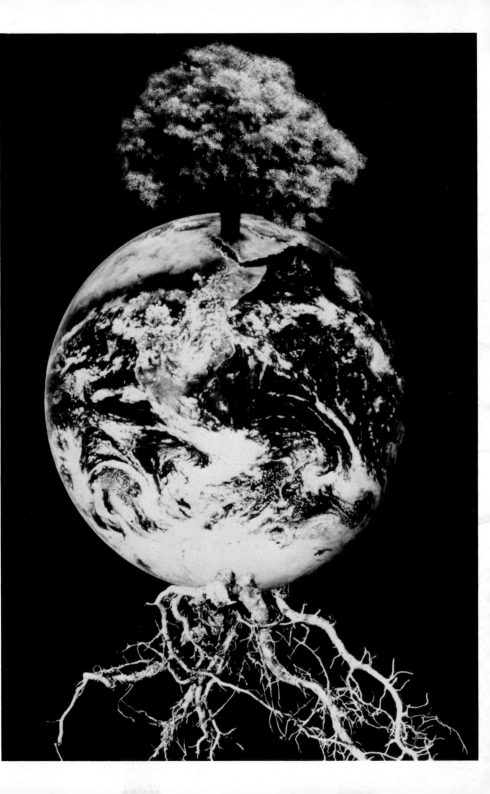

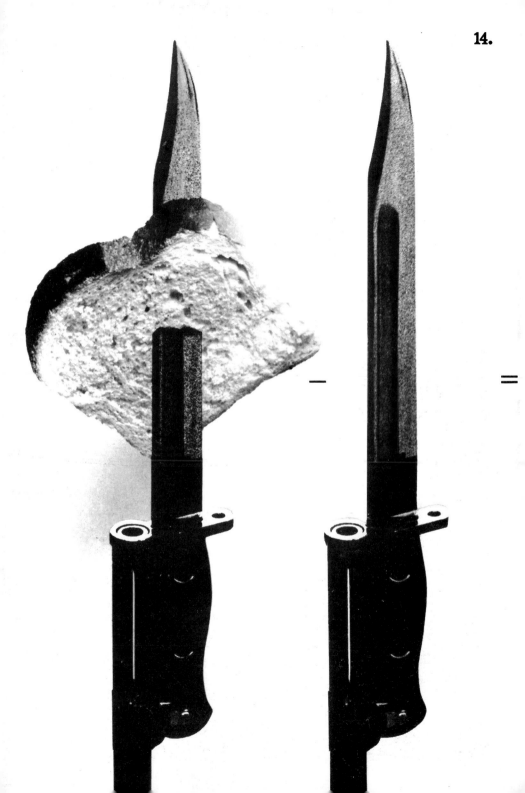

14.

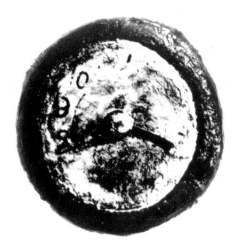

This is a photograph of a wristwatch. The wristwatch was found in the water, 150 meters downstream from the Motoyasu Bridge in Hiroshima. It shows the exact time of the bombing.

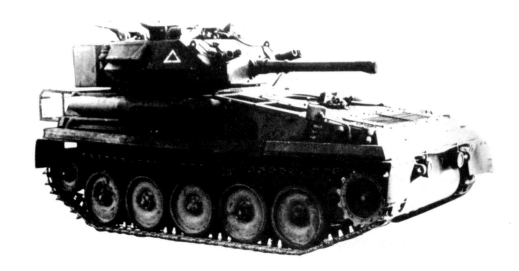

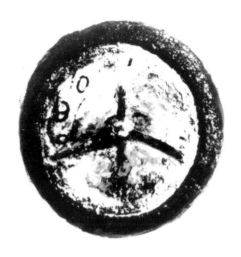

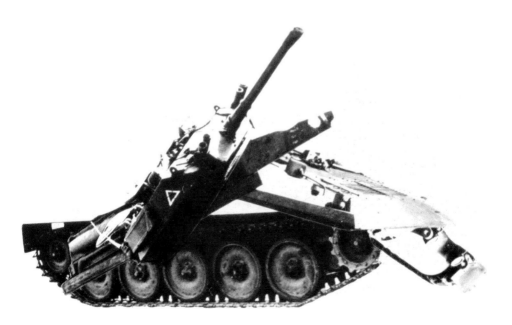

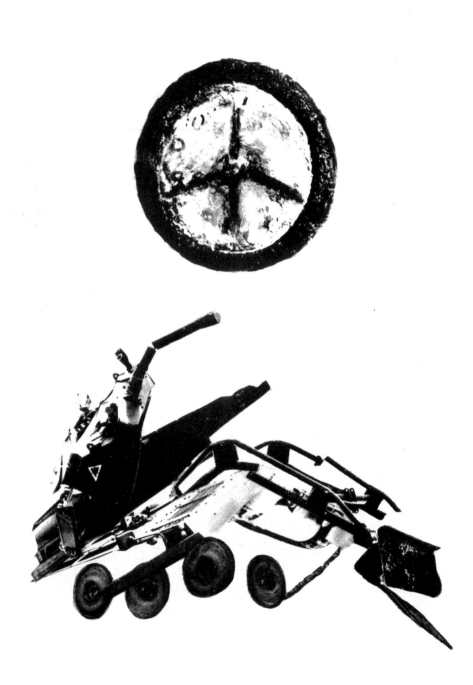

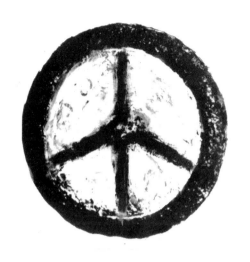

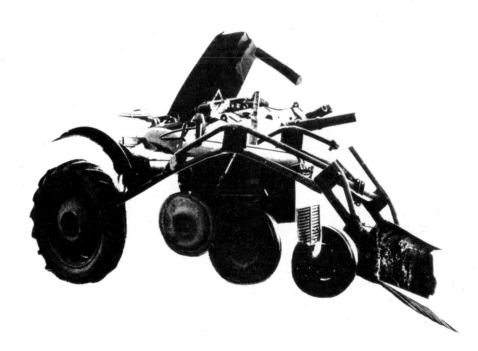

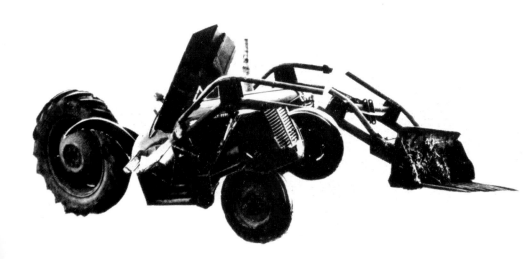

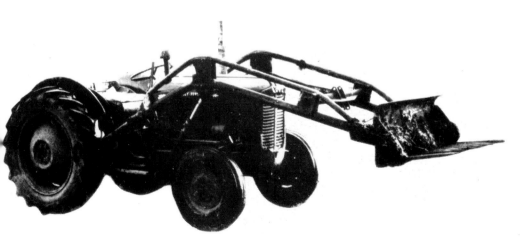

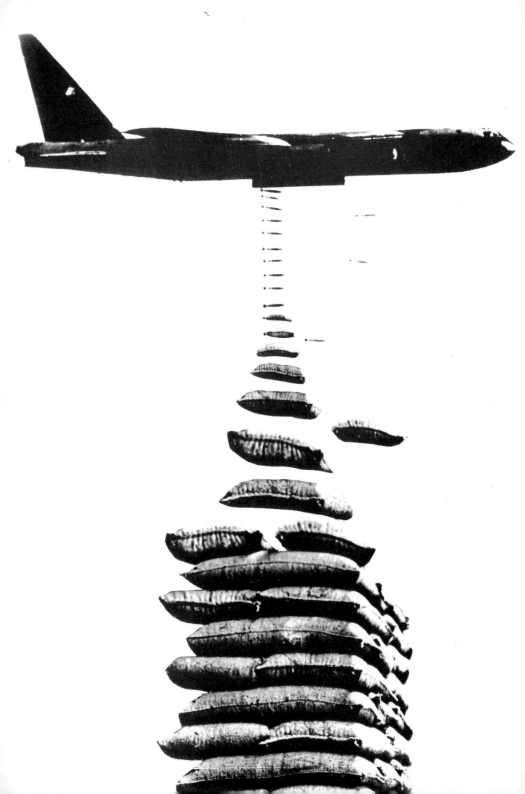

Afterword

Our world contains terrible equations. One billion dollars, the cost of twenty modern military planes, equals what it would cost to control the illness killing eleven million children annually in the developing world. The single click of a camera shutter cannot picture this connection, cannot equate one with the other. But in a photomontage two clicks can be brought together to create a third meaning.

The photomontages in this book try to develop an international picture language - a set of visual equations without captions. Each photograph I have used is like a syllable standing next to another syllable to form a word. Each word is a photomontage put next to another to make up a visual sentence. The images are to be read. They must speak for themselves.

This is an essay on photomontage not an explanatory introduction, which would be a denial of the form of the book. By writing about the medium of photomontage and my own experience as a practitioner, I hope I will encourage people to think critically about the daily flood of images to which we are subjected. Because my own medium is visual, these background notes might help to elucidate some of the problems involved in developing a political art.

My photomontages attempt to rip apart the smooth, apparently seamless surface of official deceit to expose the conflict underneath. I try to make visible the possibilities for disarmament, grounding abstraction in material images. Through changes of scale, a missile and a grain of corn can be made to equate with each other. A tank is shown in stages turning into a tractor, like a socialised transformer toy. What may appear to be a far-fetched image has a basis in fact. Workers in armament factories have developed detailed plans for arms conversion, using existing plant to develop socially useful products. Gorbachev discusses the possibilities for arms conversion. The

phrases 'tanks into tractors' or 'swords into ploughshares' have become cliches through over-use. But they are over-used because they reflect deep human desires. An image that can visualize that cliche and put it back into living circulation in a new form can ground those desires in visual fact. The equation with which I began these notes is terrible because it exists, but also because we know that it needn't.

By breaking down elements in photographs, cutting them up and reconstituting them, a critical narrative on opposing futures can be presented visually. The resultant images are not documentary mirrors (although some of my photomontages only exist as a result of the bravery of documentary photographers who go out into the world while I sit in a room trying to make sense of the images they bring back), but visual maps of human choice. My photomontages are constructed to show that events are not as natural and inexorable as they often appear to be in photographs, but the result of a set of choices and decisions. They aim to subject photographic images to human criticism.

Making visual connections allows me to break through the sea of media images in which sometimes I feel I am drowning. A number of theorists and artists accept that the media landscape is so all-encompassing that it confounds the ability to make sense of images and deduce meaningful connections that bear some relation to actual events. This betrays a pessimism that places the artist outside the events of history as a passive receiver rather than an active critic of our times. Possibilities exist for artists to create international image banks that act as a critique of the everyday world, that imagine new worlds and that act as an early (late) warning system of what could happen to the planet ecologically and politically. It is increasingly necessary for artists to ring visual alarm bells.

In 'A Small History of Photography', Walter Benjamin quoted Brecht as saying that 'less than ever does the mere reflection of reality reveal anything about reality. A photograph of the Krupp works or A.E.G. tells us next to nothing about these institutions. So something must in fact be built up, something artificial

posed.' Today, sixty years later, this statement is even more pertinent. Not only does the camera fail to record the human relationship to the products of the factory; it also overlooks the by-product of that factory, pollution, which is threatening the fabric of the planet. Today, computer technology, electronic communication, multinationals and surveillance all create webs of power. The problem is to make the invisible, visible.

What does a photograph of a computer tell us? Not that our personal histories are recorded on disc and that one database can relay information to another. How can we 'picture' 'the Disappeared' - people who are torn from their houses at night and rendered invisible by authoritarian regimes? Does a photograph of a Defence Minister in a newspaper show that another section of the Social Services is being destroyed in one country to pay for weapons intended to destroy the people of another? What does a photograph of a nuclear power station tell us? Not that its radioactive emissions can cause birth deformities.

Increasingly the 'expert' is wheeled in by the state to reassure communities who have become aware of the unseen threat to their area from local technology. The public relations literature produced by the nuclear power industry is full of photographs of male 'experts' in immaculate white coats staring hard at mysterious pieces of technology. The implied message is that they understand it, they are in control. When the nuclear reactor went critical in Three Mile Island, Pennsylvania, in 1972, a local inhabitant was reported as saying 'A lot of people didn't understand the threat because they couldn't see it. It would have been different if the radiation had blown over us in a red cloud which people could have seen rather than this invisible gas.' The problem is to find a visual analogy to that invisible gas, to envisage the red dust.

We know that the nuclear weapons industry has developed an anodyne language in an attempt to foreclose thinking about nuclear war. Our final moments on earth could well be the result of what we have learnt to describe as a 'nuclear exchange'. The power of eighteen Hiroshima bombs is contained in each euphemistically named Cruise missile. But

perhaps more insidious because less obvious are visual images produced by the nuclear industry itself. I have in my possession a British Ministry of Defence leaflet extolling the virtues of the Cruise missile. In it, the missiles and the gentle English landscape in which they are depicted are both painted in delicate watercolour washes, presumably by the chief Ministry of Defence water-colourist (a job of the utmost dialectical complexity). The irony is immense: watercolour is the favoured medium of landscape painters, used to express their love of nature.

To counter these kinds of images, and the endless pictures of missiles and idealised warfare, it is not enough to change the surrounding words and leave the image intact. The images have to be broken and ways found to picture critically something whose effects we have only seen in photographs from Hiroshima. Those photographs are horrifying but their message must be brought into the present. The realities of nuclear war have become softened and domesticated to such an extent that Athena Posters, a few years ago, produced a large full-colour uncaptioned poster of a nuclear explosion, to put up on our bedroom wall. It was to be found in their catalogue under the heading 'The 20th Century - Power and Energy' - next to a poster of an American breakdown truck!

The point of my work is to use these easily recognisable iconic images, but to render them unacceptable. To break down the image of the all-powerful missile, in order to represent the power of the millions of people who are actually trying to break them. After breaking them, to show new possibilities emerging in the cracks and splintered fragments of the old reality.

I studied as a painter, but after the events of 1968 I began to to look for a form of expression that could bring art and politics together to a wider audience. I found painting increasingly problematic: the sensuality of the medium tended to take over the subject of the painting. The viewer intentionally related the painting back to the problems of art history, whatever the subject. I found however that photography wasn't as burdened with similar art historical associations. Although my work is

obviously related to the pioneering photomontages of John Heartfield from the 1930s, people are still forced to link the images back to the actual world (the traces of reality recorded by the camera) rather than to purely formal concerns.

My photomontages are also easily reproducible and this has enabled me to show work in a number of different contexts, from my local launderette to the United Nations in Geneva. They have also been used as an image resource by anti-nuclear, environmental and human rights campaigns. They have appeared in newspapers, on TV and films, posters, tee-shirts, postcards, badges etc. Local campaigning groups have produced their own versions of the images in sculptural form, on banners and murals. For me, getting the work out into the world and used is as important as its production. The photo-montages are not only reports on events and possibilities but become part of those events themselves when they are used by the people campaigning for change.

My work can also provoke by being exhibited in institutions. In 1989 I held an exhibition at the Barbican Centre in London. On the night before opening it was deemed necessary by the management to cover one large photomontage with a blanket and to remove another from the wall. At the last minute, the management had realised that a Chilean Finance Minister (who was to give a lecture to financiers the following morning in the Barbican) would walk through my exhibition on his way to the lecture. The two censored works from which he was protected showed images of the Chilean Army in action.

The enormous changes sweeping the world open up possibili-ties and an underlying fear. Ghosts of the past inhibit the optimism generated by the recent events in Eastern Europe. East meets West. New maps of the world are drawn up. Real disarmament proposals are discussed . The compass shifts axis. Newer forms of socialism - or a West hungry to consume an impoverished East. From the broken fragments of the Cold War new images are being constructed. The changes are more than just a temporary blip on the screens of the world's money markets.

Images of new alliances which can destroy the weapons of destruction must be found. Images constructing alternatives in which the poverty of the thinking behind the arms race can be brought face to face with the poverty created by that race. Governments haven't ceased to deceive or mislead - as I glanced at today's newspaper I read the following: 'The military spending cuts now beginning to take effect among the main powers may disguise a continual expansion in firepower, a new study of weapons of mass destruction warns today. Research on new kinds of nuclear weapons is not being constrained by disarmament negotiations, the authors point out, and some modern conventional weapons are almost as devastating as small nuclear weapons.'

There is no let-up.

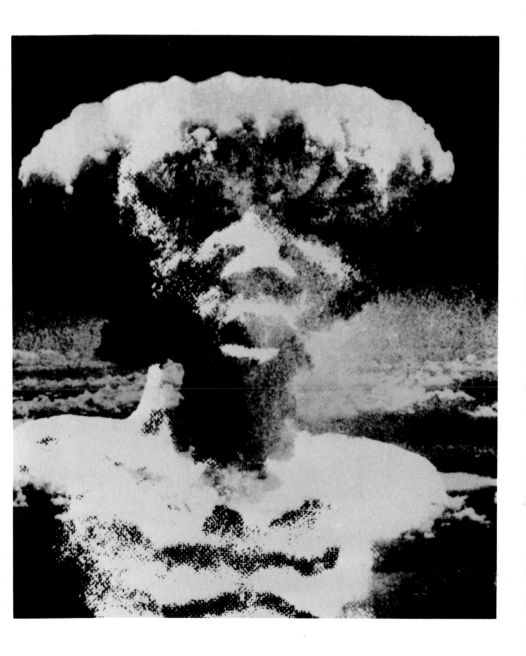

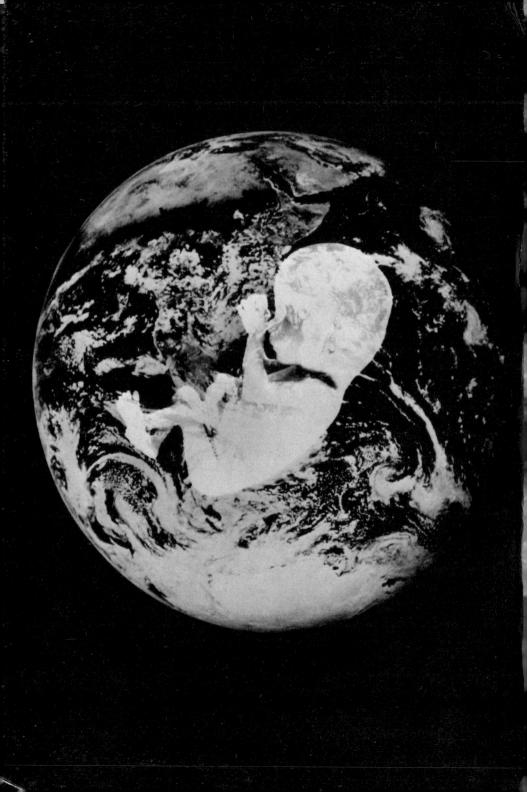